NEW SALEM

· A HISTORY OF ·
LINCOLN'S ALMA MATER

JOSEPH M. DI COLA
FOREWORD BY TERRY W. JONES

The History Press

Published by The History Press
Charleston, SC
www.historypress.net

Copyright © 2017 by Joseph M. Di Cola
All rights reserved

Front cover, top: photo courtesy of Gene Cook; *bottom*: Library of Congress.
Back cover: from Thomas P. Reep, *Lincoln and New Salem*.

First published 2017

Manufactured in the United States

ISBN 9781467136204

Library of Congress Control Number: 2016950690

Notice: The information in this book is true and complete to the best of our knowledge. It is offered without guarantee on the part of the author or The History Press. The author and The History Press disclaim all liability in connection with the use of this book.

All rights reserved. No part of this book may be reproduced or transmitted in any form whatsoever without prior written permission from the publisher except in the case of brief quotations embodied in critical articles and reviews.

I dedicate this work to my grandsons Joseph, Christian and Maximus, in the hope that they will develop a keen interest in and love for history.

—Papa Joe

Reconstruction of the Second Berry and Lincoln Store at Lincoln's New Salem State Historic Park. *Illinois Regional Archives Depository, University of Illinois at Springfield.*

CONTENTS

Foreword, by Terry W. Jones 7
Acknowledgements 9

1. Founding of New Salem 13
2. Residents 21
3. Nonresidents 36
4. Plat and Site Maps 47
5. Abraham Lincoln at New Salem: 1831–1837 51
6. "Salem, Indeed, Is Desolate": The Site after 1840 78
7. Reconstruction Phases 86
8. New Salem Today 105

Notes 111
Bibliography 119
Index 123
About the Author 127

FOREWORD

"I get this feeling every time I come to New Salem. It's like something happened here that can't be quite explained. Something happened to Abraham Lincoln," states the narrator in the orientation film *Turning Point* at Lincoln's New Salem State Historic Site.

The facts of the "happening" during Lincoln's relatively short time at New Salem are but fireflies in a twilight of scarce documents, distant memory, tradition, legend and lore. This matters little, however, because this strange thing, this happening, is not as elusive as the facts. It is, rather, imprinted in the place where Lincoln walked; you can feel it. You gain a sense of place walking through the village, seeing the buildings, hearing the animals, smelling the fires, feeling the heat, the cold, the rain, the sun.

This book is a companion to this journey of senses and emotion, to engage the "happening" of Abraham Lincoln. It provides context by telling the stories of the places, the people and the young Lincoln himself in this unpretentious but significant village.

It is a story of a raw, rough, uncertain Abraham Lincoln as he navigated relationships, failures and victories. It is also the story of people who knew "honest Abe" and saw something in the young man that compelled them to invest their scarce resources and respect—and a few who didn't. Finally, it is a story of a place that, by fate or randomness, became the "safe place to fail" for young Abraham. He grew in character and stature. The town prepared him to meet his destiny, his "happening."

Foreword

Lincoln's New Salem State Historic Site is a national shrine. Hundreds of thousands of Americans and others from all over the globe make the pilgrimage to "walk where he walked." This book provides the opportunity to meet the people of New Salem who worked with and supported Lincoln when he walked here. If you listen and watch closely enough, you might catch a glimpse or hear the resonance of this strange thing and feel the tinge of what happened to Abraham Lincoln at New Salem.

<div style="text-align: right;">
Terry W. Jones

Site Interpretive Coordinator

Lincoln's New Salem State Historic Site

2016
</div>

ACKNOWLEDGEMENTS

The September 15, 1952 issue of *Life* featured an article on a photograph of Abraham Lincoln in his coffin that had been discovered by fourteen-year-old Ronald Rietveld. The youth had found the photograph in the papers of Lincoln's secretaries, John Nicolay and John Hay, which were then housed in the Illinois State Historical Library. I was fascinated by the account of how the photograph had been taken, the controversy over the image, its disappearance from the historical record and its rediscovery. I asked my father if we had any Lincoln books. We did, and I started reading them. My father started taking me to the Lincoln sites, including New Salem. I was eleven years old, and this was the beginning of my lifelong love of, interest in and research on Abraham Lincoln.

I had originally planned to write a series of biographical sketches, for possible publication in a history journal, of the New Salem residents who I believe were instrumental in shaping Abraham Lincoln into the person he became. One day I received an e-mail from my friend Rob Wick. He lamented the fact that there had not been a newer, full-scale treatment of New Salem and Lincoln's time there since Benjamin Thomas's *Lincoln's New Salem*, first published in 1934. Rob's words inspired me to undertake this larger project, and I thank him for that and for sharing information he had on Lincoln and New Salem from the Ida M. Tarbell papers at Alleghany College. I spoke of my idea with two other friends, Gene and Joy Cook, when they came to Troy to see the Lincoln funeral train replica, and they encouraged me, too. I said that I was struggling with a title and mentioned

Acknowledgements

that William Barton, an earlier Lincoln biographer, referred to New Salem as Lincoln's "alma mater"; Joy suggested I use some form of that for the title, and I thank her for the suggestion. I first met Rob, Gene and Joy in 2013 when we came together as part of what has become an annual trip to the Springfield, Illinois area to join with other Lincoln "people" to tour the local sites associated with the man who became the sixteenth president of the United States. In fact, it was Gene who came up with the idea for the annual visits and invited others to join in.

I also thank the personnel at the Abraham Lincoln Presidential Library in Springfield, Illinois, for their research assistance: Glenna Schroeder-Lein, manuscript librarian, and Gwen Podeschi, reference librarian, who made the arrangements for my research visit; Debbie Hamm in the manuscripts department, who had the materials available that I had requested and who went above and beyond to find other files that were of great help to me; Roberta Fairburn of the audio-visual department, who tracked down photographic images of some of the original New Salem residents; Jennifer Ericson, of the Lincoln Collection, who made available to me the "CCC New Salem Construction Photographic Album" and other images and documents; and James Cornelius, curator, Lincoln Collection, who offered several suggestions that made my visits to the library even more fruitful. The research facilities at the Abraham Lincoln Presidential Library, warm and inviting, are made even more so by the friendliness of the staff.

Thanks to Thomas Wood, university archivist, archives/special collections in the Norris L. Brookens Library, University of Illinois at Springfield, for giving me access to the Rebecca Veach New Salem Research files and the 1829 Reuben Harrison plat of New Salem and for tracking down images taken of the barren site toward the end of the nineteenth century and from the 1918–19 reconstruction efforts. Thanks, too, to his assistant Allison Bates for her help during my visit.

Many thanks to Terry Jones, site interpretive coordinator at Lincoln's New Salem State Historic Site, for writing the foreword to this work. It captures the magic that visitors feel when they experience the village. Thanks to him, too, for corrections and additions to the chapter on New Salem today.

My thanks also go to Ben Gibson, commissioning editor at The History Press, for his encouragement and support. He shepherded the idea through the publisher, provided valuable assistance in the selection and scanning of the images appearing in this volume and was always available, and I learned a lot from him. I was very fortunate when Rick Delaney was assigned to be the copy editor. Sometimes when I was so focused on the text I ended up

Acknowledgements

missing the obvious on stylistic matters, but Rick's experienced eye directed me to where changes needed to be made. Thanks for all of the editorial help, Rick. Also, kudos to Natasha Walsh for her inspired design of the book's cover.

For both non-extracted and extracted quotations, I chose to keep the original grammar and spelling, adding only end punctuation where it seemed to be needed. Finally, any errors are solely mine.

—Joseph M. Di Cola

1

FOUNDING OF NEW SALEM

Sangamo country is gently rolling prairie with tall grasses, wildflowers and timber consisting of oak, elm, ash, walnut, maple, sycamore, hickory, cottonwood and nut- and fruit-bearing trees. In the early nineteenth century, there were good sources of potable water from the Sangamon River and its tributaries.[1]

In 1829, eleven years after Illinois became the twenty-first state, New Salem was founded on a bluff above the Sangamon River at a place where the river bends sharply north from its westerly course. The founders were James Rutledge, born in South Carolina on May 11, 1781, and John M. Camron, born in Georgia in 1790. Its life span can be measured in what the poet Robert Burns described as "short and simple annals," lasting from 1829 to 1840, when it no longer existed.

Rutledge and his family moved from South Carolina to Georgia, then to Tennessee and later to Henderson County, Kentucky. There, on January 25, 1808, he married Mary Ann Miller (born on October 21, 1787, near Winsboro, South Carolina). In 1813, James, Mary Ann and the first three of their eventual ten children moved to White County, Illinois. During their time there, the Rutledges had four more children. John Camron, a nephew of Mary Ann Rutledge, followed the same path from Georgia, Tennessee, Kentucky and into White County, Illinois.

Rutledge and Camron later moved to Sangamon County, where they settled on Concord Creek, entered land and made plans to construct a dam and mill. The depth and flow of water was not enough to operate

mill machinery, so in July 1828, they entered land a few miles farther south on the Sangamon River and filed a petition with the state legislature to dam the river. The petition was granted in early 1829. Meanwhile, in the autumn of 1828, the two families settled on land entered on the bluff overlooking the west bank of the river and built log homes.

Rutledge and Camron were not the first to occupy the site. Archaeological evidence indicates that prehistoric Native Americans occupied the site; before 1828, pioneer settlers did as well.[2]

There were two smaller streams in the vicinity of New Salem, one located south between two bluffs and known as Green's Rocky Branch and another to the north known as Bale's Branch. Both of these emptied into the Sangamon River.

Once permission was granted by the state, work on the dam commenced by sinking log cribs side by side into the river. These were filled with rocks hauled to the site by local farmers. A combination grist- and sawmill was constructed of heavy timbers, and the whole structure was set onto pillars made of rock-filled wooden cribs. The gristmill was completely enclosed, while the room for the saw was a roofed shed open at two ends. A split-log bridge connected the mills to the bank at the bottom of the bluff. "Notwithstanding the extreme simplicity of this mill, it was a 'big thing' in that early day, for mills were so scarce…that people came from a distance of fifty and even one hundred miles in every direction, to have their grain ground in this mill. Such was the patronage given to this enterprise, that the proprietors determined to lay out a town adjoining the mill property."[3] A contemporary account describes the mill's operation:

John Camron (pictured) and James Rutledge founded New Salem in 1829. Camron's trade was that of millwright, but he was also an ordained Cumberland Presbyterian minister. *From Thomas P. Reep,* Lincoln and New Salem.

> *In those days people went to mill on horseback; if a farmer wanted to send four sacks to mill he sent four boys with a two bushel sack on each horse, and it was sometimes said that he would fill grain in one end and a rock in the other end to balance. It might have been the case when it was a jug*

A History of Lincoln's Alma Mater

This is the only picture in existence of the actual surroundings and the original grist- and sawmill at New Salem. *From Thomas P. Reep,* Lincoln and New Salem.

> *in one end. Fancy, if you please, forty horses hitched up the sides of a steep hill with their heads forty-five degrees higher than their hams, and forty boys fishing or in swimming, or playing fox and geese on the bottom of the "Miller's Half Bushel," and you have a good idea how the boys spent their time when they went to mill.... The mill ran all year.*[4]

On October 23, 1829, John Camron, the holder of the land title, secured the services of surveyor Reuben S. Harrison to plat the site (originally known as Camron's Mill), and the town of New Salem was born. Harrison's certification reads as follows:

> *State of Illinois*
> *Sangamon County.*
> *I Reuben S. Harrison, Surveyor, do hereby certify that at the request of John Cameron* [sic], *one of the proprietors, I did survey the town of New Salem, of which the within is a complete Plat, that all of the lots are 115½ feet*

front, and 115½ feet back, the Main Street is 60 feet in width, and runs West and South to the Public Square, from thence West 15 degrees South, that all the other streets are running square across the Main Street. Given under my hand this 23d day of October, 1929.

Reuben Harrison[5]

In a letter to William Herndon dated June 4, 1866, John McNamar declared:

I however, Claim to be the first Explorer of Salem as a business point, Mr Hill (Now Dead) and myself—purchased Some Goods at cincinnatti [sic] and Shipped them to Saint Louis whence I set out on a voyage of Discovery on the prairies of Illinois…soon came across a Noted Character who Lives in this vicinity by the name of Thos. Watkins, who set forth the beauties and other advantages of Camerons [sic] Mill as it was then called I accordingly came home with him visited the Locality contracted for the Erection of a Magnificent Store house for the Sum of fifteen Dollars…. Others soon followed.[6]

Villages like New Salem were the commercial centers for the surrounding areas, which included farms and homesteads consisting of a few log houses sited near trees and streams. New Salem had a grist- and sawmill, cooperage, blacksmith shop, hatter shop, wheelwright and cabinetmaking shop, carding mill and wool house, tannery, several stores (some of which also served as taverns), shoemaking and leather repair shop, ferry, two doctors, an inn and a school that doubled as a church meetinghouse. The stores sold a limited variety of comestible and dry goods and, if so licensed, liquor by the drink. The village residents also produced items for themselves, including soap, clothing, candles, bedding and other household necessities. Businesses were set up in a room in residents' houses or were located nearby. The village was sited along a road that facilitated travel to and from the outlying areas; however, travel was very difficult during wet seasons. A stage line passed through New Salem, connecting it to towns such as Springfield. New Salem's settlers dreamed of the day when the Sangamon could be made navigable so that goods could be easily transported from *entrepots* farther away. Hunting and fishing provided food, and the settlers planted gardens and kept livestock at New Salem, including horses, cattle, hogs, sheep, oxen and chickens. The vegetable gardens, located near the houses, contained white beans, potatoes, sweet potatoes, peas, onions, cucumbers, turnips, asparagus, beets, carrots,

lettuce, radishes, pepper grass, tomatoes and seed corn. Residents picked crab apples, plums and cherries from nearby trees and consumed dried fruit that was usually imported from New Orleans.[7]

For amusement, the residents had races, wrestling and shooting matches, dances, house raisings, quilting bees and barbecues. Residents also engaged in political and camp meetings, debates, temperance and literary societies and the simple activity of sitting around talking. Not to be forgotten was gander pulling, in which a live goose with a well-greased head was attached to a rope or pole that was stretched across a road; a man riding on horseback at full gallop would attempt to grab the bird by the neck in order to pull the head off. Despite such pastimes, life on the frontier could be brutal and often exacted its toll through extreme weather events and diseases beyond the capacities of mid-nineteenth-century medicine. T.G. Onstot remembered:

> *At the time that Mr. Lincoln lived Salem was a great place of resort for the young men. Boys from Clary's Grove, Wolf county, Sangamon and Sand Ridge would gather together at Salem on Saturday and there indulge in horse racing, foot racing, wrestling, jumping, ball playing and shooting at a mark for beef. A beef always had five quarters when shot for. The hide and tallow made the fifth quarter. The boys also indulged in gander pulling, which was, I think a western game.*[8]

John McNamar's letter to William Herndon of November 25, 1866, offered the following description of the inhabitants of New Salem:

> *Its history, the manners habits and customs of the People of those days was of that Primitive order that usually characterize New Settlements with an abundance of the necessities of life, its luxuries were unknown or uncared for Lavish hospitality and Brotherly love abounded and every where* [sic] *the Latch string hung out to all comers, The Majority of the Citizens were professing Christians or church members.*[9]

Religion played a part in the lives of these pioneer residents of New Salem. There were no purpose-built churches, so meetings were held in schoolhouses or private residences. At annual camp meetings, a central structure was usually erected. Here, the people gathered to sing and listen to preaching. The families lived in shelters set up around the central meeting place. Women prepared the meals for the campers in a location behind the campsites.[10]

The largest denominations were the Hardshell Baptists, Cumberland Presbyterians and Methodists. Peter Cartwright, a Methodist circuit rider, preached at Pleasant Plains near New Salem and at camp meetings. These gatherings were often characterized by emotional outbursts, including much jerking of the bodies of those present.[11]

According to pioneer T.G. Onstot:

> *There was sound preaching in those days. The preachers preached hell and damnation more than they do now. They could hold a sinner over the pit of fire and brimstone till he could see himself hanging by a slender thread, and he would surrender and accept the gospel that was offered to him.*[12]

In the book *The History of Menard and Mason Counties, Illinois*, is found this observation:

> *Often the pioneer preacher, with no companion but the horse he rode, would start across the wide prairies, with no guide but the knowledge he had of the cardinal points, or, perhaps, a point of timber scarcely visible in the dim and hazy distance, and, reaching the desired settlement, would present the claims of the Gospel to the few assembled hearers, after the toilsome and lonely day's journey; then after a night of rest in the humble cabin and partaking of the simple meal, he again enters upon the journey of the day, to preach again at a distant point.*[13]

Often, rowdies who had been drinking would show up and create a commotion, while valiant attempts were made to put them onto the path of righteousness and conversion.

The 1834 *Gazeteer of Illinois, in Three Parts* by J.M. Peck described New Salem as

> *a post office and town, located in Sangamon county, on the south west side of Sangamon River, on a bluff, and surrounded with a large settlement. It has three or four stores, and thirty families. A grist and saw mill is here, erected on Sangamon river. It is on section twenty-five, eighteen north, seven west.*[14]

And Carl Sandburg, in volume one of *The Prairie Years*, wrote of the village:

> *The sawmill, the gristmill, the stores, and the post office of New Salem drew customers from different localities.... The people mostly traced back to Kentucky and Virginia families.... They were corn-fed. The grain that came in sacks, slung over horses riding to the mill at New Salem dam, was nearly all corn, seldom wheat or rye. The mill ran all the year, and the people ate corn six days in the week and usually on Sunday. Milk and mush, or milk with corn-bread crumbled in it, was the baby food. For the grown-ups there were corndodgers.*[15]

In his *Pioneers of Menard and Mason Counties*, T.G. Onstot adds this further observation and a bit of hyperbole:

> *On Sunday morning, if we children had been good all week, then we had biscuit and preserves. The meal was used principally for corn dodgers. Two quarts of meal were mixed with cold water, with a little salt added, and the cook would grease the skillet and make three pones that fit in the skillet, and as the finishing touch would give it a pat and leave the print of her hand on the bread, and then with a shovel of coals on the skillet lid, would bake it so hard that you could knock a Texas steer down with a chunk of it, or split an end board forty yards offhand.*[16]

The kitchen tools available to the pioneers were described "as few and simple as can be." These included a flat Dutch oven or skillet, frying pan, iron kettles, coffeepot and various hand utensils. There were no stoves; cooking was done on the fireplace, and kettles were hung on hooks over the fire or, in the case of Dutch ovens, were placed directly on the coals with additional coals placed on the lids for baking.[17]

Clothing worn by the pioneers who settled in New Salem was also plain and simple. On arrival at the village, people made do with the clothing they brought with them. After a time, it was made using local resources. Cotton goods were scarce, and both climate and the length of the growing season were not conducive to the cultivation of cotton. Initially, wild nettles were gathered to make "nettle linen," which produced a fiber that could be spun and woven. Later, the settlers planted crops of flax whose fibers were woven into linen cloth that was used to make underclothing, dresses, table linen, towels, shirts and other items.[18]

Once a sufficient number of sheep were raised and could be protected from wolves, wool was used to produce flannel, linsey-woolsey and jeans. Plant dyes such as walnut bark were used. Before Samuel Hill built the

carding mill, all wool was carded by hand. Families spun the wool on their own spinning wheels, and some households also had looms.[19] Men and boys also wore pants and shirts made from buckskin. For footwear, moccasins were common for men, women and children.

Farming implements were primitive: wood mold-board plows for breaking the ground, hoes for cultivation, sickles or, later, the scythe-and-cradle. Plows were hitched to oxen, singly or yoked together in teams of up to six or more. Plowing was accomplished at a "fearfully slow pace, dragging the ponderous plow, as it steadily crushed through turf and roots, turning over the long and evenly [sic] sod; and, notwithstanding the tardy pace at which they moved, owing to the width of the furrow, a considerable amount of land would be plowed in a day."[20]

Pioneer villages like New Salem were founded and settled by people who intended to purchase land, build houses and either farm or ply a trade. They were preceded by waves of migrants who, first, were hunters and trappers and, later, squatters who remained in an area for a short time and then moved on. It was those who remained on the land that brought morals, religion and education into the frontier. Among those who settled at New Salem, some were illiterate. Others, like Jack Kelso, Dr. John Allen and James Rutledge, possessed varying degrees of education, intellect and training. Those from New England brought values characterized by strict habits, severe religious views and sound business sense; settlers from Virginia lived by the values of high honor, courage and a more liberal philosophy. Both sets of values would bring their influence to bear on Abraham Lincoln. Education was another value shared by those who settled at New Salem, reflected in the building of a school and the hiring of a schoolmaster. A literary society was established in 1831 by New Salem's co-founder, James Rutledge, who owned twenty-five books. Of those living in the New Salem area, four attended Illinois College at Jacksonville: William F. Berry, David Rutledge, William G. Greene and Lynn McNulty Greene. In an August 1834 letter to his mother in New Hampshire, Charles J.F. Clarke wrote: "Jacksonville College is doing more for this country than any eastern man could expect.…They [the students] almost astonish the old folks with their learning when they come home."[21]

2
RESIDENTS

There were other settlements within a fifteen-mile radius of New Salem, but the town's grist- and sawmill attracted customers from the surrounding area. It also attracted entrepreneurs, like Samuel Hill and John McNeil, who built and opened a store in the fall of 1829 that sold groceries, including whiskey, and dry goods. McNeil was an alias used by John McNamar to mask his identity until he made a fortune, enabling him to bring his family to Illinois. When the post office opened on Christmas of that year, Samuel Hill became New Salem's first postmaster. Lots were being sold, and on most of them, homes, commercial enterprises or a combination of both were being built.

The following biographical sketches are for persons who resided in and conducted business at New Salem and whose houses and enterprises are part of the present-day reconstructed town. Other former citizens of New Salem also may be mentioned in these biographies.

James and Mary Ann Rutledge continued to reside in the house he erected on the south side of the road and where three of their ten children were born. James was a fairly educated man who had a library of several books in his home. He established a debating society in the community.

In 1831, Rutledge converted his house into a tavern and put on an addition to accommodate overnight guests. Nelson Alley purchased the tavern and in 1834 sold it to Henry Onstot, who later sold to Michael Keltner. In 1837, the tavern was sold to Jacob Bale.

New Salem

The Rutledges left New Salem in 1833 and moved to a farm at Sand Ridge, where James died on December 3, 1835. He is buried in Old Concord Cemetery. There is an unsightly cenotaph commemorating him as a founder of New Salem, but this does not mark his actual burial place in the cemetery, which is unknown. In 1836, James's widow, Mary Ann, moved to Fulton County, Illinois, and later settled at Birmingham, Iowa, where she died on December 26, 1878. She was buried in Bethel Cemetery.

Ann Rutledge was born to John James and Mary Ann Miller Rutledge on January 7, 1813, in Henderson County, Kentucky. Except for her association with Lincoln during her short life, little is known about Ann. Descriptions of her vary widely. She has been described as "fair, with blue eyes, hair very light, verging into auburn, and slightly built."[1] In *Pioneers of Menard and Mason Counties*, T.G. Onstot described Ann:

Mary Ann Rutledge was the spouse of New Salem co-founder James Rutledge and the mother of Ann. The Rutledges left New Salem in 1833, moving to nearby Sand Ridge. *From Thomas P. Reep,* Lincoln and New Salem.

> *She was...of medium size, weighing 125 pounds and had flaxen hair. She was handsome and attractive, as well as industrious and sweet spirited. It was seldom that she was not engaged in some occupation—knitting, sewing or waiting on the table."* [2]

In a March 1887 interview with William Herndon, Parthena Hill stated that "Ann Rutledge had a [*sic*] brown hair—heavy set."[3] According to Lynn McNulty Greene, the brother of William G. Greene, in a May 3, 1866 letter to Herndon: "She was of medium height plump & round in form weighed 150 lbs Eyes blue not large & Hair a golden yellow Modest & unassuming in bearing."[4] From Herndon's interview with Mentor Graham on April 2, 1866, Ann was described in this way:

> *She was about 20 ys* [sic]—*Eyes blue large, & Expressive—fair complexion—Sandy, or light auburn hair—dark flaxen hair—about*

5-4 in—face rather round—outlines beautiful—nervous vital Element predominated—good teeth—Mouth well Made bautiful [sic]—*medium Chin—weigh about 120–130—heart & vigorous—Amiable—Kind.*[5]

In Herndon's 1866 interview with Esther Bale, Ann is spoken of this way: "Had auburn hair—blue Eyes—fair Complexion—slim—pretty—Kind—tender good hearted woman—height about 5 feet 3 in—weighed about 120 pounds."[6] In a July 7, 1865 letter to Herndon James Short, who lived a short distance from the Rutledge farm at Sand Ridge, this is said of Ann: "Miss R was a good looking, smart, lively girl, a good house keeper, with a moderate education, and without any of the so called accomplishments."[7] And in a letter to G.U. Miles, John McNamar, Ann's one-time fiancé, wrote: "Miss Ann was a gentle Amiable Maiden without any of the airs of your city Belles but winsome and Comly [sic] withal a blond in complection [sic] with golden hair, cherry red lips & a bonny Blue Eye."[8]

The biographical sketch of John McNamar (later in this chapter) discusses Ann's engagement to him and its dissolution. In 1833, when the Rutledges moved to a farm in the Sand Ridge community north of New Salem, Lincoln is said to have visited and courted Ann. It was there that she became fatally ill with typhoid and died on August 25, 1835. She is buried in Old Concord Cemetery.

In 1890, Samuel Montgomery, undertaker and furniture dealer from Petersburg and secretary of Oakland Cemetery, thought that having Ann Rutledge's remains buried there would increase sales of plots. When the grave at Old Concord was opened, there was no trace of a body, only a few pearl buttons from her dress. These and some dirt were removed to Oakland. Due to their decomposition, Ann Rutledge's remains were not and could not be removed and, therefore, are still at one with the soil of Old Concord Cemetery.[9]

John Camron's occupation was that of millwright, but he was also an ordained

Mary Ann Rutledge was born on October 21, 1787, near Winnsboro, South Carolina. She died on December 26, 1878, and is buried in Bethel Cemetery, Birmingham, Iowa. *Van Buren (Iowa) Historical Society.*

Ann Rutledge was born on January 7, 1813, in Henderson County, Kentucky. She died on August 25, 1835, and is buried in Old Concord Cemetery. *Photo by author.*

Cumberland Presbyterian minister. He and his wife, Polly Orndorff, were married in Kentucky and had one son and eleven daughters. The house he erected in 1828 at New Salem was near the Rutledge dwelling. The current reconstruction of New Salem does not have a Camron residence. According to archaeologist Robert Mazrim, the reconstructed Rutledge tavern was inadvertently placed on the site of the original Camron home, which later became the Bale family residence until the 1860s. In 1874, it was the last structure standing on the abandoned site of New Salem.[10]

In 1832, Camron sold the grist- and sawmill to Jacob Bale, who operated that structure long after New Salem was deserted.[11] The *Sangamo Journal*, a newspaper published in Springfield that promoted the common interests of Sangamon County, ran an ad on September 29, 1832:

> *For Sale, New Salem Saw and Grist Mill*
> *This valuable property, situated on the Sangamon River, will be sold on good terms. No description is necessary, as any person desirous of purchasing will examine the premises.*
>
> *John Camron*[12]

John Camron and his family left New Salem in 1833, moving to River Prairie in Fulton County, Illinois. They eventually went to Big Cedar Creek in Jefferson County, Iowa, and to Oskaloosa. John later resettled in California, where he died on February 2, 1878. He was buried in Sebastopol Memorial Lawn Cemetery at Sebastopol in Sonoma County. There is no marker on his grave, but it is in the vicinity of the marked graves of his first and second wives.[13]

New Salem's first lots were purchased on Christmas Eve 1829 and January 4, 1830, by James Pantier for $12.50 and $7.00, respectively, although no structure was erected on them. Pantier was born at Boones Fort, Kentucky, in 1779 and arrived in Illinois in 1815. Not much else is known about him except for a recollection made by T.G. Onstot in 1902 that he "was an eccentric character. He was a faith doctor and could cure snake bites and mad dog bites."[14] It is also known that he served as a judge in an election for representatives to Congress on October 27, 1834, at which Abraham Lincoln and Mentor Graham acted as clerks.[15] His son, David, served as a private under Lincoln in the Black Hawk War. James Pantier died in 1859 and is buried in Old Concord Cemetery, north of New Salem.

Another person about whom little is known is David Whary, who purchased Lot 12 on December 19, 1831. It is not known whether he erected a house on the lot; however, on May 5, 1834, he acted as one of three judges at the election of the Sangamon County sheriff.[16] It is thought that Whary moved west. Philemon Morris, a tanner, built a residence and started a tannery before leaving and moving west. Henry Sinco, born near Richmond, Virginia, on February 13, 1800, moved to Kentucky around 1820. He learned the trade of chimney builder and plasterer and came to New Salem in the fall of 1831. He served as constable, opened a tavern and, within months, sold out to Dr. Francis Regnier. Sinco is known to have married Jane Bennett and moved eventually to Iowa, where he settled in a number of locales. He died in 1874 and is buried in Lillie Cemetery in Decatur County, Iowa.[17]

When George Warburton came to New Salem in 1831, he built and stocked a store, the only structure that was clapboarded. (It later became the second Berry-Lincoln store.) He soon sold out to Isaac Chrisman and his brother St. Clair, both of whom very shortly sold out and moved away. Other than what is known of his association with Peter Lukins and the founding of Petersburg, Warburton's biography is sparse. He was a heavy drinker and died from drowning after a drunken spree. His dates of birth and death and location of burial are unknown. Pioneer communities experienced

population shifts as people moved in, stayed briefly and moved on. As a result, little or nothing is known of those individuals who made New Salem a fleeting part of their biographies.

William Clary was born in Tennessee in 1800 and, after moving to Illinois, married Sarah E. Greene in 1819. In late 1829, he opened a grocery at the east end of the village. Being a grocery, it also served as a saloon selling whiskey and other liquor. Since it was on the bluff nearly opposite the mill below, those who were waiting for flour or lumber orders could make purchases, have a drink and socialize with others. It also became the hangout for the Clary's Grove boys, a bunch of rude, rough and rowdy men. The area around the store became the site for cockfights, wrestling matches and other forms of pioneer sport. In 1830, Clary started to operate a ferry, which afforded New Salem trade access to communities eastward across the Sangamon River. In 1833, Clary left the store to Alexander Trent and the ferry to James Richardson. He then moved to Texas, first settling in Smith County and later in Navarro County, where he died from pneumonia in May 1870.

Much of Samuel Hill's early biography is lost in the mists of time. He was born in Hunterdon County, New Jersey, on November 12, 1800, and moved to Cincinnati, Ohio, in 1820. But the first extended span of his life of which we are aware begins with his arrival in 1829 in New Salem, where he and his business partner opened the village's first general store. Such enterprises were often the first to appear in the pioneer villages that emerged from the Illinois prairie in the early to mid-nineteenth century. Some merchants began auspiciously, but many of these later failed. However, Hill was successful, and his businesses thrived during his stay. He had a volatile temper but a good head for business. It was said he was so tight-fisted that when he got a coin in his hand, he would squeeze it so hard that the eagle screamed. Twice each year, Hill traveled to Beardstown and boarded a steamboat to St. Louis, where he stayed for a week or more to purchase goods for the store. His establishment became a center of village life where people gathered to talk idly or discuss specific topics, pass the time of day, vote on election days (shared with other polling places) and, of course, make purchases. "A stock of goods in those days would be a curiosity now. His standard goods were blue calico, brown muslin, and cotton chain for the weaver. No luxuries were indulged in. There was no canned fruit then, no dried fruit, as the farmers brought in dried apples and peaches. Hill's store was headquarters for all political discussions. The farmers would congregate there and discuss the questions of the day."[18] His partnership with John McNeil (McNamar) ended in 1832.

Samuel Hill became the village's first postmaster when the post office opened on Christmas Day 1829. This was a boon to New Salem, since it meant that the residents no longer had to travel twenty miles to Springfield to get their mail. Hill served in that position until November 1831, when, for a brief time, Isaac Chrisman held the post, only to have Hill resume as postmaster when Chrisman sold his business and moved away. Hill remained postmaster until Lincoln was appointed to succeed him on May 7, 1833.

In the spring of 1835, Hill built a four-room house on a lot immediately west of his store, the only two-story residence in the village. The larger room on the first floor served as parlor, dining room and kitchen; the smaller one was used as a store and utility room. On the second floor, the larger room at the front was a bedroom, and the small room at the rear served as a closet and hall for the stairs. The house also had a front porch. On July 28, 1835, Hill married Parthena Nance, who was born in Green County, Kentucky, on August 13, 1816. She and her parents came to Illinois in 1832, settling at Farmer's Point outside New Salem. Samuel and Parthena Hill had one child, John, born in New Salem in 1839.

Earlier in 1835, Hill built a carding mill west of where he would erect his house. An advertisement was placed in the *Sangamo Journal* on April 24, 1835:

Samuel Hill arrived in New Salem in 1829; he and his business partner opened the village's first general store. He had the only two-story house in the town. *Lincoln's New Salem State Historic Site. Photo by author.*

> *Wool Carding*
> *The subscriber respectfully informs his customers and the public generally, that he will commence carding by the first of May next. The machines are nearly new and in first rate order, and I do not hesitate to say, the best work will be done. Just bring your wool in good order, and there will be no mistake.*
>
> *Samuel Hill*[19]

Since he was busy with his mercantile business, he retained the services of Hardin Bale to operate the mill.

> *Every person kept sheep in those days, and took the wool to the machine where it was carded by taking toll out of the wool or sometimes they would pay for it. They commenced bringing in wool in May and by June the building would be full. It was amusing to see the sacks of all sorts and sizes and sometimes old petticoats. For every ten pounds of wool they would bring a gallon grease, mostly in old gourds. Large thorns were used to pin the packages together.*[20]

In 1837, Hill sold the carding mill to Bale and, in 1839, moved his family and his store building to the new town of Petersburg, where he continued to be a successful businessman.[21] Samuel Hill died on November 14, 1857, and Parthena passed away on July 1, 1898. They are buried in Petersburg's Rose Hill Cemetery.

When John McNamar (aka McNeil) came to New Salem in 1829, he was in partnership with Samuel Hill, with whom he erected and opened a store. He was born in New York in 1801 to somewhat affluent parents. When his father experienced financial reverses, John set out west to make his fortune, after which he planned to bring his family to join him.

Sometime in 1831 or 1832, he became engaged to Ann Rutledge, the daughter of James and Mary Ann. On September 4, 1832, he sold his interest in the store to Samuel Hill and ended his partnership with him. John McNamar had realized his goal of accruing a fortune, allowing him to travel to New York and bring his family back with him to Illinois. Before leaving New Salem, he told Ann of his real name and the reason for his alias, which was to keep his kin from finding him until he had become successful. He had purchased a farm a short distance from New Salem and promised Ann that they would be married when he returned. On his way to New York, while in Ohio, he became seriously ill. After recovering, he finally arrived at his family home. While there, his father became ill, dying several months later. It took another several months to take care of family matters, and John wrote to Ann to explain the delay. Ann wrote back, but years went by, and correspondence between the two came to an end. Friends of Ann and her family thought all of this sounded rather shady and suspected that John had jilted her. He did not return until after Ann's death in 1835, left New Salem in 1837, married around 1840 and lived in the area until his death on February 22, 1879. His burial place is

in Concord Cemetery (not to be conflated with Old Concord Cemetery, where a different John McNamar is interred).

Henry Onstot was born near Danville in Gerrard County, Kentucky, in 1805 and married Susana Schmick (1802–1867). In 1825, he moved to Sugar Grove, Illinois, and then from Sugar Grove to New Salem in 1830. There he erected a house and adjoining cooperage near the bluff at the southeastern end of the village. In 1833, he moved into the Rutledge inn, which he operated for two years. In 1835, when better materials were available, he rebuilt his house and cooperage south of the western end of the road that ran through the village. In 1840, he disassembled his dwelling and cooperage and re-erected them on Main Street in the new town of Petersburg. The cooperage was discovered in Petersburg in 1922, the original logs covered in clapboard. It was moved to its former site and restored to its original appearance when New Salem was reconstructed. It is the only original building from the village.

In 1846, Henry Onstot moved again, this time to Mason County, where he lived in the Havana area and continued in the cooperage business for twenty-two years. He then moved to live with his son Thomas in Forest City, Illinois, where he died on August 1, 1876. He is buried in Havana's Fullerton Cemetery.

John Rowan Herndon was born in 1807 in Kentucky. He was married there in Green County on December 28, 1828, to Mentor Graham's sister Elizabeth. The Herndon brothers, Rowan and James, arrived at New Salem in 1831 and constructed a house and opened a store (now known as the first Berry-Lincoln store); the village now had three general stores. (One of the stores was owned by Reuben Radford, who was bought out by Lincoln and Berry in January 1833.) In the summer of 1832, James wanted to leave New Salem and sold his interest in the Herndon brothers' store to William F. Berry. Rowan, in turn, sold out to Lincoln, who became a partner with Berry. When James left New Salem, he moved to Columbus, Illinois (Adams County), and then to Quincy, where he found work in several occupations.

When the steamboat *Talisman* passed through New Salem in 1832, Rowan Herndon piloted it on the return trip to Beardstown, with Lincoln as his hired assistant. On January 23, 1833, while cleaning a rifle, the firearm accidentally discharged, striking Herndon's wife in the neck and killing her. Rowan Herndon left New Salem and moved to the community of Island Grove (Sangamon County) and then to Columbus, where he worked in several capacities. He died on November 23, 1882, in Galesburg, Illinois,

New Salem

and is buried at Hope Cemetery. The Herndon brothers were cousins of Abraham Lincoln's future law partner, William Herndon.

Dr. John Allen, born near Chelsea, Vermont, on March 30, 1801, studied to be a physician at Dartmouth Medical School and graduated in 1828. He migrated west to establish a medical practice and seek his fortune, arriving at New Salem in 1831. On August 18, he purchased for twenty-five dollars the two lots that James Pantier originally owned and built his three-room house across the road from and just south of the Hill residence and store. It had a chimney made entirely of stone, at the time a mark of someone who could afford such a luxury.

He founded a temperance society, was a member of the debating club and taught Sunday school. Josephine Craven Chandler's description of the residence states:

> *At this house he established the first, and possibly the only, Sunday School, and organized the Temperance Society; and here the Rev. William Berry, father of that profligate son who was to become the business partner of Lincoln, frequently raised his voice in exhortation. The Debating Society, already in function in 1831, was doubtless one of his means to expression for the faith that was in him; and one wonders what positive but well-tempered arguments employed, on occasion, the evening leisure when before the open door or, in winter, the roaring fire....Dr. Allen and James Rutledge, whose religious tenets were embraced by the same creed but whose geographic derivation implied so wide a divergence in social customs and ideas, came to issue.*
>
> *A touch of gracious, if plain living and high thinking was here, no doubt. For the silk hat and well made saddle bags of Dr. Allen, still in evidence, attest the gentility of his way of life.*[22]

On November 7, 1833, the temperance society published by request a "Report of the New Salem Temperance Society."

> *The Society held its annual meeting at New Salem on the 7th, instant, at which the following report was read;*
>
> *Two years have passed since the formation of this society. One would naturally suppose that an object so important, as that of reclaiming or rescuing an individual from ruin, would meet with universal approbation. But when an enterprise is undertaken which has in view the happiness and prosperity of a nation, it would seem that it should*

be the happiness of every individual to be foremost in the work.

To accomplish an important revolution in the state of society, when it has become corrupt, has, in all ages, been a difficult and unpleasant work, and met by much opposition.

The temperance reformation has been met at every corner by the most determined opposition, by men whose appetites have control over their judgment, or whose avarice leads them to disregard the best of good of their neighbors and who can sacrifice every principle of honor upon the altar of their own lusts. It aims a death blow at one of the most powerful allies of Satan. It wields only the weapons of plain, common sense argument and sound reason. It aims to show men that they can live, and enjoy life, liberty and happiness, without the use of ardent spirits. Its object is to relieve our fellow citizens from the cause of a large share of our misery.[23]

Dr. John Allen founded a temperance society, was a member of the debating club and taught Sunday school. He moved to Petersburg around 1838. *From Thomas P. Reep,* Lincoln and New Salem.

On March 24, 1834, Dr. John Allen married Mary E. Moore of the Indian Point community. Unfortunately, she died in 1836. He later married the sister of Dr. Charles Chandler and moved in 1838 to Petersburg, where he continued to practice. He died on April 1, 1863, and is buried in Rose Hill Cemetery. After Dr. Allen's departure, the residence was occupied until 1840 by an unknown tenant and, from 1840 to 1842, by Henry Traylor. The house probably decayed into ruin after that.[24]

A person often associated with Abraham Lincoln's first days at New Salem is Denton Offutt. He was born in Kentucky between 1804 and 1807 near Nicholasville in Jessamine County. He stopped briefly at New Salem in April 1831 and returned in September of that year, purchased a lot near William Clary's grocery and opened a store. Earlier, in July, he had obtained a license to sell merchandise. Offutt, who had no head for business, failed as a merchant and closed the store a year later. He left New

Salem in 1832, presumably to avoid his creditors. He returned south and worked as a horse "tamer"—in today's parlance, a "horse whisperer."

The following notice appeared in the *Vincennes Western Sun & General Advertiser* on December 27, 1834:

> *$25 REWARD Escaped from the Jail in Knox county; state of Indiana, on the 13th inst. a man by the name of Denton Offutt: supposed to be between thirty and thirty-five years of age, about six feet high, dark complected, black hair; is very talkative and wishes to pass for a gentlemen [sic]; one of his upper fore teeth is out. He will probably make his way to the state of South Carolina or Georgia. The above reward will be given if he is secured in any jail without this state, or delivered to me in Vincennes.*
> *JOHN PURCELL, Sh'ff. K.C. Dec. 15th, 1834—49—tf* [25]

In the 1850s, Offutt was living in Baltimore, Maryland. In a letter sent to William Herndon in 1873, Dr. James Hall, a physician living near Baltimore, wrote:

> *Some twenty-five years ago one "Denton Offut" [sic] appeared in Baltimore, hailing from Kentucky, advertising himself in the city papers as a veterinary surgeon and horse tamer, professing to have a secret to whisper in the horse's ear, or a secret manner of whispering in his ear, which he could communicate to others, and by which the most refractory and vicious horse could be quieted and controlled. For this secret he charged five dollars, binding the recipient by oath not to divulge it. I know several persons, young fancy horsemen, who paid for the trick. Offut [sic] advertised himself not only through the press, but by his strange attire. He appeared in the streets on horseback and on foot, in plain citizens' dress of black, but with a broad sash across his right shoulder, of various colored ribbons, crossed on his left hip under a large rosette of the same material, the whole rendering his appearance most ludicrously conspicuous.* [26]

Denton Offutt also wrote a book in 1853 and registered, or "entered it according to Act of Congress," at Washington in March 1854: *The Educated Horse: Teaching Horses and Other Animals to Obey at Word, Sign, or Signal, to Work or Ride; also, the Breeding of Animals, and Discovery in Animal Physiology, and the Improvement of Domestic Animals*. It has been reported that, years later, a Petersburg resident by the name of Tom McNeeley told Abraham Lincoln he had been in Mississippi and saw Offutt demonstrate the taming of wild

horses by whispering in their ears and selling the secret word to farmers for five dollars each. Offutt asked about New Salem residents and sent a particular message to Lincoln. Lincoln asked McNeeley to "tell it just as Offutt said it." The latter replied, "Tell Lincoln to get out of his rascally business of law and politics, and do something honest, like taming horses," causing Lincoln to laugh and say, "That's Offutt, that's just like Offutt."[27]

Offutt is reported as last seen in 1859 and is thought to have died in 1860. His burial place is unknown.

Peter Lukins, originally from Kentucky, also arrived at New Salem in 1831 and built a house, operating his shoemaking and leather repair business out of one of the rooms. Lukins didn't remain long at New Salem. He and George Warburton owned 160 acres of land farther north of the village and in 1832–33 laid out a town that became Petersburg—named after Peter Lukins. This occurred after Lukins and Warburton played a game of "old sledge," the winner getting the naming rights.[28]

Petersburg did not immediately rise, and eventually Lukins and Warburton sold the land to Hezekiah King and John Taylor, who later employed Abraham Lincoln to resurvey and plat the site in late 1835 and early 1836. At the same time, there was a movement to separate the northern half of Sangamon County and create a new county because of the increased population in that area. On February 15, 1839, the Illinois legislature created Menard County and made Petersburg the county seat. This, added to the fact that the post office was moved from New Salem to Petersburg on May 30, 1836, sealed New Salem's fate. As people moved away, their land was often bought by Jacob Bale. His first investments in New Salem were his purchases of the grist- and sawmill in 1832 and Samuel Hill's carding machine and wool house in 1835. Eventually, the Bales ended up owning the entire site.

After his move to Petersburg in 1832, Peter Lukins continued his trade as a cobbler, but he also owned a tavern. He was a heavy drinker and, depending on the source, died either after an alcoholic binge or by his own hand due to poisoning. His dates of birth and death are not known, but he is buried in Petersburg's Rose Hill Cemetery.

A number of people continued to settle in New Salem. Among them were Isaac Burner, born in Kentucky on September 24, 1784, and his wife, Susan, born on March 15, 1786. He purchased two lots from John Camron, built a house and, in 1834, left New Salem to move near Knoxville, Illinois, where he died on July 7, 1860. He and Susan (died on May 22, 1855) are buried in Abingdon Cemetery, Knox County, Illinois. Isaac Guliher, born at

Hopkinsville in Green County, Kentucky, on June 23, 1815, married Burner's daughter Elizabeth on August 23, 1831, at New Salem, where he had built a house. They moved in 1834 to Knox County, Illinois, where, according to an 1870 atlas map of Knox County, he worked as a brick-maker. He died on March 14, 1888, but his place of burial is unknown.

Joshua Miller and John "Jack" Kelso are notable for having sisters for wives (John married Nancy Jane Connelly on December 24, 1840) and for building a dogtrot cabin that shared a common roof. The Kelsos had no children and lived in the one-room structure on the west end of the double dwelling; the Millers and their two children, Caleb and Louise, resided in the two-room structure on the east end. In the warmer weather, the open space served as dining and sitting space for both families. Miller built a blacksmith shop east of the double house and was one of the busiest men in the community. Kelso and his spouse had an occasional boarder, but except for odd jobs at which he excelled, Jack was unemployed. He was well educated and loved to fish, hunt and "recite Shakespeare and Burns by the hour."[29] In 1836, both men pulled up stakes and left New Salem. Kelso was reported to have been in the area until 1840, when he moved farther west. Miller bought a farm nearby. Their places and dates of birth and death and burial places are not known, except for a reference in the Illinois Archives to a Kelso family Bible that records Jack's date of death as November 6, 1870.

The well-educated Dr. Francis Regnier moved to New Salem in 1832 from Marietta, Ohio, where he was born in 1808. He bought the Henry Sinco house and converted the one room into his living space and office. By 1834, he was married to Sophia Ann Goldsmith and had moved to Clary's Grove, but he continued to maintain his practice at New Salem. He later moved to Petersburg, where he died on September 14, 1859. He is buried in Rose Hill Cemetery.

Martin Waddell also arrived in 1832, built a house and worked as a hatter. "Waddle [sic] made hats for 50 cents out of rabbit fur, and hats of coon fur as high as $2."[30] He and his family were gone by 1838, moving farther west. Philemon Morris, who arrived in 1832, erected a house and set up a tannery that, according to the J. McCan Davis map of 1896, was located between Miller's blacksmith shop and the Waddell house. It is not part of the reconstructed New Salem. After Peter Lukins departed, Alexander Ferguson moved into the house in 1832 and took over the shoemaking and leather repair business until he left in 1840 and purchased a farm nearby. Robert Johnston, a wheelwright and maker of spinning wheels, looms and other furnishings, arrived in 1832 and erected a house. The main room and

lean-to were the family living quarters and shop, respectively. It is assumed that they left during the exodus of 1836–40. Alexander and Martin Trent also arrived in 1832 and built a house on a lot they purchased on August 27. Alexander bought William Clary's grocery, and his brother Martin was licensed to operate the ferry on the Sangamon River formerly run by Clary. They were involved with various litigations, including one against Abraham Lincoln. On March 12, 1832, in *The People v. Martin Trent*, Justice of the Peace Bowling Green fined Trent three dollars on the charge of assault and battery.[31] Other biographical data for these persons, including places of burial, are unknown. A reference in the Illinois Archives reports that Alexander Trent died in 1854.

William F. Berry had a short life. He was born in Warren County, Kentucky, on January 8, 1811. However, he has gained immortality through his business association with Abraham Lincoln. On March 6, 1833, the Sangamon County commissioners court issued to Berry and Lincoln a tavern license, namely, the right to sell liquor.

William's father was the Reverend John McCutcheon Berry, a minister of the Cumberland Presbyterian Church. He lived at Rock Creek and traveled to New Salem and other communities to preach. He assisted Dr. John Allen in organizing the local temperance society.

As mentioned earlier, the Herndon brothers, Rowan and James, opened a store in 1831. In the summer of 1832, James Herndon wished to leave New Salem and sold his share in the store to William F. Berry. Rowan, not wanting to be in partnership with Berry, sold out to Lincoln, who then partnered with Berry. In January 1833, Lincoln and Berry also bought Reuben Radford's store. The site of this first Berry and Lincoln partnership is known as the first Berry-Lincoln store.

Berry also served as a corporal under Captain Lincoln in the Black Hawk War. Sadly, William Berry was an alcoholic and died on January 10, 1835, leaving Lincoln deeper in debt. Berry's drinking had led to the end of Lincoln's partnership with him. On April 29, 1833, Lincoln turned over his interest in the store to Berry. He is buried in the Berry family plot at Rock Creek Cemetery.

3
NONRESIDENTS

John "Jack" Armstrong was born on January 13, 1801, in White County, Tennessee. He was the son of Revolutionary War veteran Robert A. Armstrong and Nancy Green Armstrong. Around 1825, he married Hannah Jones, who was born on August 8, 1811, in Kentucky. Sometime in the 1830s, the Armstrongs moved to Sangamon County, Illinois, where he was a member of the notorious Clary's Grove boys. Being the strongest, he became their leader.

Jack Armstrong and Abraham Lincoln became great friends after their celebrated wrestling match at New Salem. Lincoln was a regular visitor to the Armstrong home, occasionally staying and having his meals there, and Hannah washed and mended his clothes. "Hannah said, 'Abe would come out to our house, drink milk, eat mush, corn-bread and butter, bring the children candy, and rock the cradle while I got him something to eat. I foxed his pants, made his shirts. He would tell stories, joke people, boys and girls at parties. He would nurse babies—do anything to accommodate anybody.'"[1] In exchange, Lincoln performed a number of chores, including babysitting for William "Duff" Armstrong, a person he later successfully defended on a murder charge. Jack also served as a sergeant under Captain Lincoln in the Black Hawk War.

The Armstrongs later moved north and lived on a farm near Petersburg and then went to Walker's Grove in Mason County, Illinois, where Jack died on September 9, 1857. He is buried next to his father, Robert, in Old Concord Cemetery in Menard County. In August 1862, Hannah married

Left: Jack Armstrong and Abraham Lincoln became great friends after their celebrated wrestling match at New Salem. Lincoln was a regular visitor to the Armstrong home. *Lincoln's New Salem State Historic Site. Photo by author.*

Right: Lincoln occasionally stayed with the Armstrongs and had his meals there, and Hannah washed and mended his clothes and made his shirts. *From Thomas P. Reep,* Lincoln and New Salem.

Samuel Wilcox (born in Kentucky in 1812). Samuel died on August 22, 1870, in Easton, Crane County Township, in Mason County and was buried in Big Grove Cemetery. His grave is unmarked.

Hannah moved to Winterset in Madison County, Iowa, where she died on August 8, 1890. Her remains were returned to Illinois, where she was buried in Petersburg's Oakland Cemetery. Her grave marker reads "Hannah Wilcox," but a wooden sign marked "Hannah Armstrong" points the way to her place of burial.

Bowling Green was born in North Carolina on January 25, 1786. In Tennessee, he met and married Nancy Potter (born in South Carolina) and, sometime in the early 1820s, moved from there to Illinois along with his mother and stepfather (Revolutionary War veteran Robert Armstrong and the father of Jack Armstrong). Eventually, the Greens lived on a farm a half mile north of New Salem. In the June 1832 term of

the commissioners court of Sangamon County, Bowling Green was one of three men appointed judges of election in the New Salem precinct.² He also served the local area as justice of the peace. "Bowling Green was acquainted with the statutes and Lincoln spent hours in the Green home talking about the statutes. Nancy Green, the squire's wife, cooked hot biscuit smothered in butter and honey, doughnuts, and cookies to eat with buttermilk, apples, and sweet cider."³

In *Lincoln and New Salem*, Thomas Reep provides the following description of Bowling Green:

> He was a very large man, weighing more than 250 pounds but under six feet in height. His stomach was large and protuberant, causing him to be nicknamed "Pot." He had a beautiful complexion, his skin being smooth, with the pinks and white of a woman.⁴

Thomas adds this description:

> He loved to laugh, and as he presided over court, [was] clad only in a shirt and trousers held up by one linen suspender over the shoulder.⁵

Top: Hannah Armstrong Wilcox was born on August 8, 1811, in Kentucky. She died in Winterset, Iowa, on August 8, 1890, and is buried in Petersburg's Oakland Cemetery. *Photo by author.*

Right: Bowling and Nancy Green lived on a farm a half mile north of New Salem. They took care of Lincoln after the death of Ann Rutledge. *From Thomas P. Reep,* Lincoln and New Salem.

He and his wife housed and took care of Lincoln after the death of Ann Rutledge. On the evening of February 13, 1842, Bowling Green went to the nearby home of Bennett and Elizabeth Abell, where he died suddenly of a stroke. The next day, he was buried on a hillside just north of his home. "In the spring the Masons came down from Springfield…uncovered the grave and had their ceremonies. Lincoln was the orator of the occasion."[6] Nancy Green died on December 20, 1867. The Greens are buried in Petersburg's Oakland Cemetery.

Bennett Howard Abell was born in Washington County, Kentucky, on October 9, 1796. Elizabeth Attaway Owens was born in Green County, Kentucky, on August 6, 1804. They were married in St. Mary's County, Maryland, on August 21, 1815. They lived outside New Salem on a farm neighboring that of Bowling and Nancy Green. Abraham Lincoln was an occasional visitor and boarder at the Abells.

In 1833, Elizabeth Abell invited her sister Mary Owens (born on September 29, 1808) to come from Kentucky to Illinois for a visit, during which she first met Abraham Lincoln. Lincoln thought her a comely and intelligent girl. Mentor Graham, in an interview on April 2, 1866, described Mary Owens:

Bowling Green was born in North Carolina on January 25, 1786. He died on February 13, 1842. Nancy Green died on December 20, 1967. They are buried in Petersburg's Oakland Cemetery. *Photo by author.*

> *Miss Owens: she was about 28—black Eye over medium size—hair black—symmetrical face—features roundish—tolerably fresh—good natured, Excellent disposition—about 150 &c—5-4 inches—6—She was a very intellectual woman—well educated—and well raised—free and social—beautiful & Even teeth—gay and lively—mirthfullness [sic] predominant—billious [sic] temperament.*[7]

In the fall of 1836, a year after the death of Ann Rutledge, Elizabeth went to Kentucky for a return visit and jokingly suggested to Lincoln that she would return with her sister if he would promise to wed Mary, to which Lincoln agreed. When Mary Owens arrived back at New Salem, Lincoln remarked on changes in her appearance. She was not as attractive, had put on a lot of weight and was wanting in some of her teeth.[8] However, true to his word, Lincoln intended to press his suit of her. In a letter of April 1, 1848, written to Mrs. Orville H. Browning, Lincoln rather unchivalrously describes his reactions to the changes in Miss Owen's appearance:

> *In a few days we had an interview, and although I had seen her before, she did not look as my immagination [sic] had pictured her. I knew she was over-size, but she now appeared a fair match for Falstaff; I knew she was called an "old maid," and I felt no doubt of the truth of at least half the appellation; but now, when I beheld her, I could not for my life avoid thinking of my mother; and this, not from withered features, for her skin was too full of fat, to permit its contracting in to wrinkles; but from her want of teeth, weather-beaten appearance in general, and from a kind of notion that ran in my head, that nothing could have commenced at the size of infancy, and reached her present bulk in less than thirtyfive [sic] or forty years; and, in short, I was not all pleased with her.*[9]

On December 13, 1836, Lincoln wrote to Mary from Vandalia, expressing his feelings of depression since leaving New Salem and arriving in the capital:

> Mary
> *I have been sick ever since my arrival here, or I should have written sooner. It is but little difference, however, as I have verry [sic] little even yet to write. And more, the longer I can avoid the mortification of looking in the Post Office for your letter and not finding it, the better. You see I am mad*

about that old letter yet. I dont like verry [sic] *well to risk you again. I'll try you once more any how* [sic]*.*

He goes on to discuss legislative affairs, including the possible removal of the capital to Springfield, before closing with:

> [I] *have gotten my spirits so low, that I feel that I would rather be any place in the world but here. I really can not endure the thought of staying here ten weeks. Write back as soon as you get this, and if possible say something that will please me, for really I have not* [been] *pleased since I left you.... Your friend*
>
> <div align="right">*Lincoln*[10]</div>

Mary began to see Lincoln's shortcomings as a potential spouse and, in a letter to Herndon on June 22, 1866, described a few incidents that led to her decision not to marry him:

> *I did not believe he would make a kind husband, because he did not tender his services to Mrs.* [Gaines] *Green* [a cousin visiting Mary] *in helping of her carry her babe. As I said to you in a former letter, I thought him lacking in smaller attentions....Mr Lincoln was riding with me, and we had a very bad branch to cross, the other gentlemen were very officious in seeing that their partners got over safely; we were behind, he riding in never looking back to see how I got along; when I rode up beside him, I remarked, you are a nice fellow; I suppose you did not care whether my neck was broken or not. He laughingly replied, (I suppose by way of compliment) that he knew I was plenty smart to take care of myself.*[11]

Lincoln's last letter to Mary Owens was written from Springfield on May 7, 1837. He begins by describing how dull life in Springfield is and how lonely he feels, and he mentions their past conversation about her coming to live there. He continues:

> *I am afraid you would not be satisfied. There is a great deal of flourishing about in carriages here, which it would be your doom to see without shareing* [sic] *in it. You would have to be poor without the means of hiding your poverty. Do you believe you could bear that patiently? Whatever woman may cast her lot with mine, should any ever do so, it is my intention to do all in my power to make her happy and contented....I much wish you*

would think seriously before you decide. For my part I have already decided. What I have said I will most positively abide by, provided you wish it. My opinion is that you had better not do it.[12]

There are no letters extant from Mary Owens in response to Lincoln's. However, we know that she ultimately rejected his offer of marriage.

In 1842, Mary Owens married Jesse Vineyard and moved to Weston, Missouri. In a letter written to William Herndon on May 23, 1866, she wrote: "Mr. Lincoln was deficient in those little links which make up the great chain of a womans [*sic*] happiness."[13] Mary Owens Vineyard died on July 4, 1877, and is buried in Pleasant Ridge Cemetery, north of Weston.[14]

The Abells sold their farm in the early 1850s and moved to Blandinsville Township in McDonough County, Illinois,[15] where Elizabeth died on November 20, 1869. Bennett died on May 8, 1876. They are buried in Avon Cemetery in Union Township, Fulton County, Illinois.

Mentor Graham was instrumental in Lincoln's education, tutoring him first in grammar and then in mathematics. Lincoln mastered Euclid's six books. *From* McClure's *magazine (December 1895).*

William Mentor Graham was born to Jeremiah and Mary Graham in 1800 in Kentucky. On April 27, 1817, he married Sarah Ailsa Rafferty in Green County and worked as a teacher in at least four Kentucky communities between 1817 and 1826, when the Grahams moved to Sangamon County, Illinois. Despite Graham's allegation that he saw Abraham Lincoln and his father, Thomas, working in a field in Kentucky, there is no evidence of any direct contact with the Lincolns.

Mentor Graham's first school assignment in Illinois was at the Baptist church school in the area where New Salem would be founded. He was there until 1838. He then taught from 1839 to 1840 in a new brick structure known as Salem School. The rates charged to parents for his services "ranged from thirty to eighty-five cents a month for each pupil."[16]

On the frontier, teachers and books were scarce. However, as soon as a community like New Salem was established, an existing structure such as

a church or meetinghouse was used as a schoolhouse. Some communities had a house raising for a school building. A log puncheon set onto large pins served as a long writing desk for the pupils. The bench seats were constructed in similar fashion, made from straight, twelve-inch-diameter tree trunks cut in half lengthwise and legs made of large wooden pins. These were subscription schools, where parents paid anywhere from $1.50 to $2.50 per child for a three-month term. The school day ran for nine hours. According to a contemporary account, "The teacher must be adept at making quill pens, as pens of steel or gold were then unheard of."[17]

Mentor Graham was instrumental in Abraham Lincoln's education, tutoring him first in grammar, using a copy of an 1828 edition of *Kirkham's Grammar* borrowed from a local farmer, John C. Vance. Friends would ask Lincoln questions from the book, and he would give the answers and definitions. He also studied mathematics with the help of Graham and almost mastered Euclid's six books. Lincoln also delved into history and literature. Carl Sandburg describes Lincoln's time with Graham:

> *On a ridge the other side of Green's Rocky Branch, a creek south of New Salem, stood a log schoolhouse, where Lincoln occasionally dropped in to sit on a bench and listen to the children reciting their lessons to Mentor Graham, the tall, intellectual, slant-jawed schoolteacher. He wanted to find out how much he already knew of what they were teaching in the schools. And he spent hours with Mentor Graham going over points in mathematics, geography, grammar, and correct language. The words "education" and "knowledge" were often on his lips when he talked with thoughtful people; they referred to him as a "learner." He called himself that, "a learner." The gift of asking questions intelligently, listening to the answers, and then pushing quietly on with more questions, until he knew all that could be told to him, or all there was time for—this gift was his. He could pump a man dry on any subject he was interested in.*[18]

In addition to being a teacher, Mentor was known to be a skilled craftsman, including as a brick maker. He constructed a brick home for himself and his family near New Salem.

The remainder of his career, from 1841 until 1878, was spent as a teacher at several schools and, occasionally, as a private tutor until his move to Dakota Territory (today's Blunt, South Dakota) in 1883. There, he lived with his son, Harry Lincoln Graham. He died at Blunt on November 15,

1886, and was originally interred there. His wife, Sarah, preceded him in death on March 24, 1869, and is buried at Farmer's Point Cemetery, just south of New Salem in Tallula, Illinois. On July 23, 1933, Mentor Graham's remains, which had been returned to Illinois, were laid to rest next to those of his wife. For a full treatment of Mentor Graham's life, the best source is by Kunigunde Duncan and D.F. Nickols, *Mentor Graham, the Man Who Taught Lincoln*.

William G. Greene Jr. (also known later as "Slicky Bill") was born in the fort at Bryan Station, Fayette County, Kentucky, on January 27, 1812. In the fall of 1831, he lived with his parents a few miles outside New Salem, where he was hired to work as an assistant to Abraham Lincoln at Denton Offutt's store. Like Lincoln, he was a wonderful raconteur.

Mentor Graham, born in 1800 in Kentucky, died at Blunt, Dakota Territory, on November 15, 1886. He is buried at Farmer's Point Cemetery, just south of New Salem. *Photo by author.*

He and Lincoln became fast friends and together took their meals with Bowling and Nancy Green and slept in the store. Greene's job at the store was to assess clients' credit.

Greene had a part in Lincoln becoming a merchant in his own right. In 1833, there were bad feelings between Reuben Radford and the Clary's Grove boys, resulting in the latter trashing Radford's store. A disgusted Radford announced that he would sell out to the first man who made an offer. Greene, hearing this, bought up the store for $400. The same day, he sold the stock to Berry and Lincoln for $750.

William Greene also served under Captain Lincoln in the Black Hawk War. In 1835, when Lincoln was staying with Bowling and Nancy Green after the death of Ann Rutledge, a chance meeting took place.

> *It was here upon a Sunday morning, while stretched out on a cellar door reading law, that* [Lincoln], *for the first time, met Richard Yates, who during Lincoln's presidency was war governor of* [Illinois]. *Yates had come up from Jacksonville to spend the week end with his friend William G. Greene and was taken by Greene over to Salem to meet his friend, Abe*

Lincoln. From that beginning there grew up a close and firm friendship between the two that endured during life.[19]

Greene attended Illinois College at Jacksonville. He later became a successful farmer. He was known as a shrewd businessman and became wealthy in real estate and banking and as president of the Tonica and Petersburg Railroad. In 1857, he helped lay out and found the village of Tallula. The village of Greenville was named after him.

When Lincoln was president, Greene visited him in Washington, where he was introduced to Secretary of State William H. Seward as the man who had taught Lincoln grammar, probably referring to the question-and-answer sessions that had occurred between Lincoln and Greene back in New Salem. Even though Greene was a Democrat, in 1862 President Lincoln appointed him Treasury Department collector for the Eighth (Peoria) District in Illinois.

William G. Greene died on June 30, 1894, and is buried in Greenwood Cemetery East in Tallula.

James S. "Uncle Jimmy" Short was born on February 6, 1806, in St. Clair County, Illinois. In 1822, he came to Sangamon County with his father, Jacob Short, and two brothers, Obadiah and Harrison.[20] In 1824, they moved to a farm in the Sand Ridge community north of the future site of New Salem, where Jacob died in 1825. In a letter written to William Herndon on July 7, 1865, James described his first meeting with Abraham Lincoln:

> *My first acquaintance with Mr Lincoln was in May or June 1831... and on coming into New Salem at that time, Mr Lincoln was pointed out to me by my sister, Mrs Elias Hohimer, whom Mr L. had before that time employed to make him a pair of pantaloons. Mr. L. at this time was about 22 years of age; appeared to be as tall as he ever became, and slimmer than of late years. He had on at the time a blue cotton round*

William G. Greene Jr. was hired to work as an assistant at Offutt's store and, later, had a part in Lincoln becoming a merchant in his own right. *From Thomas P. Reep,* Lincoln and New Salem.

about coat, stoga shoes [brogans], *and pale blue casinet* [lightweight twill fabric] *pantaloons which failed to make the connection with either coat or socks, coming about three inches below the former and an inch or two above the latter. Without the necessity of a formal introduction we fell in together and struck up a conversation, the purport of which I have now forgotten. He made a favorable impression on me by his conversation on first acquaintance through his intelligence & sprightliness, which impression was deepened from time to time as I became better acquainted with him.*[21]

James "Uncle Jimmy" Short helped retrieve Lincoln's horse, saddle, bridle and surveyor's instruments when they were seized from Lincoln after a court judgment was rendered against him. From Thomas P. Reep, Lincoln and New Salem.

In the same letter to Herndon, Short goes on to describe other recollections of Lincoln, including the time he helped retrieve the latter's surveying equipment that had been lost in a court judgment. After the Berry and Lincoln store "winked out" (Lincoln's words), Lincoln was unable to pay his debts. In one instance, when judgment was rendered against him, his horse, saddle, bridle and surveyor's instruments were seized. When the items were put up for auction, Uncle Jimmy bid $120, won the items and returned them to Lincoln. Short eventually experienced hardships in Illinois and decided to try his luck elsewhere.

At the time of the California gold rush, Short led wagon trains on several trips to the gold fields. He did not fare well himself in California and fell on hard times. To help his old friend, President Lincoln appointed Short an Indian agent for the Round Valley Indiana Reservation in Mendocino County. However, Short was suspended in 1863.

By 1867, he was living in Iowa (based on the date of his fifth marriage, on January 17, 1867, in Iowa). The Winterset, Iowa *Madisonian* reported on February 5, 1874, that James Short died after a brief illness. He died on January 28, 1874, and is buried in Union Chapel Cemetery in Patterson (Madison County), Iowa.

4
PLAT AND SITE MAPS

The site and village of New Salem have been the subjects of maps that were of immense help to generations of scholars in locating and reconstructing the buildings. First is the official 1829 plat of New Salem from the records of Menard and Sangamon Counties. On October 23, 1829, John Camron and James Rutledge hired Reuben S. Harrison to survey and plat the town of New Salem in Camron's name, since he held the title.[1]

In November 1866, George Spears helped the Petersburg county clerk, Mr. Hamilton, draw up a map of New Salem. They traveled to the abandoned site, where, wrote Spears, "I pointid [sic] out the different old Locations & he Mr Hamilton skitched [sic] them as I pointed them out you may rely on them as being correct."[2]

Sometime in the 1880s, Parthena Nance Hill, the widow of New Salem merchant Samuel Hill, drew a map that aided in the village's reconstruction. There was also a map drawn for William H. Herndon sometime in the 1870s or 1880s.[3] In 1892, Henry C. Whitney included a New Salem sketch map in his *Life on the Circuit with Lincoln*.[4]

In 1896, while working on *The Early Life of Abraham Lincoln*, Ida Tarbell included a map drawn by J. McCan Davis, who had been aided in his task by the surviving New Salem inhabitants.[5]

In *Pioneers of Menard and Mason Counties* (1902), there is a map and key executed by T.G. Onstot. About this he writes: "The plat of Salem is correct, as the old settlers will testify, as Mrs. Hill had it in her scrap book."[6]

New Salem

Left: The official 1829 plat of New Salem was completed by Reuben S. Harrison on October 23, 1829, for John Camron, who owned title to the land. *Sangamon County Deed Records, vol. C, 219. Illinois Regional Archives Depository, University of Illinois at Springfield.*

Below: Map drawn by J. McCan Davis especially for Ida Tarbell's *The Early Life of Abraham Lincoln*. Davis was aided in his task by surviving New Salem inhabitants. *From Ida M. Tarbell,* The Early Life of Abraham Lincoln.

Opposite: In *Pioneers of Menard and Mason Counties* (1902), there is a map and key executed by T.G. Onstot showing the positions of the Camron residence and Rutledge tavern. *From T.G. Onstot,* Pioneers of Menard and Mason Counties.

48

1. Mill and Dam.
2. Jacob Bales.
3. McNamara's Store, where Lincoln kept Post Office.
4. The Log Tavern, by H. Onstot, where Lincoln boarded from 1833 to 1835.
5. Dr. Allen's Residence.
6. Aleck Fergesson's Cabin.
7. Hill's Store.
8. Hill's Residence.
9. The Carding Machine.
10. Martin Waddle, Hatter Shop.
11. William McNeely.
12. Henry Onstot's Cooper Shop.
13. Henry Onstot's Residence.
14. Miller's Blacksmith Shop.
15-16. Miller and Kelso Residence.
17. Road from Petersburg.
18. Road from Mill—West.
19. Springfield Road—South.
20. The Lincoln Cellar, with the Three Trees Growing.
21. Grave Yard.
22. School House.
23. Gander Pulling.

New Salem

This 1909 map by Reverdy J. Onstot included two structures not shown on earlier maps (*center rear, set among trees*). He was probably aided by other surviving residents. *The Library of Congress.*

In 1909, the son of New Salem cooper Henry Onstot, Reverdy J. Onstot, drew a map that included two structures not shown on earlier maps (center rear, set among trees in the picture above). He was probably aided by other surviving residents. Archaeological work conducted by Robert Mazrim in 1994 found artifacts at the location of those two structures.[7]

5
ABRAHAM LINCOLN AT NEW SALEM: 1831–1837

In a letter to Martin S. Morris of Petersburg in March 1843, Abraham Lincoln, reflecting on his arrival at New Salem, described himself as a "strange[r], friendless, uneducated, penniless boy, working on a flatboat—at ten dollars per month."[1] He had come to Illinois from Indiana in 1830, at age twenty-one, with less than a year of formal education. Although ambitious and possessing an inquiring mind, he had limited prospects for the future.

1831

In March and early April 1831, Lincoln was in Sangamon County, where he and his cousin John Hanks and stepbrother John D. Johnston were in the process of building a flatboat at Sangamo Town for Denton Offutt. Offutt had hired the men to take a flatboat of goods—barrel pork, live hogs and corn—to New Orleans. On April 18, they left Sangamo Town and moved up the Sangamon River.

> *All went well…till the craft reached the dam erected across the river at Salem, by Cameron* [sic] *& Rutledge. Here they were doomed to trouble, for, coming to the dam with speed accelerated by the draw of the fall to such a degree that the boat, striking prow first, ran far enough upon the dam to extend the prow several feet over. This, of course, elevated the forward part of the boat, and the result was, the water came over the stern till that*

part of the boat settled to the bottom. In this dilemma, the owner of the flat proposed to get the freight ashore as best they could, and abandon the boat. Lincoln then said that he would get an augur and bore a hole in the bottom of the boat, and thus set her afloat. Some smiled incredulously, some laughed outright, while all thought it the act of a dolt. Nevertheless, an augur was procured, a hole was bored in the bottom of the boat near the bow where it projected over the dam. The bow was then lowered, when, of course, the water in the stern ran to the front, and, as the bow extended over the dam, it ran out, and, in a very short time a pin being driven into the hole the boat was again afloat. By a little care, the "flat" was gotten safely over the dam, reloaded, and they pursued their course down the river.[2]

Lincoln and the other crew members moved the boat to the bank and went ashore. Offutt introduced himself and the others, but it was Lincoln, at six feet, four inches tall, who became the center of attention. In the short time they were at New Salem, Offutt took in the possibilities that the town had to offer an "entrepreneur" like himself. On his return from New Orleans, he intended to open a store. He arranged with Lincoln to serve as clerk for him, while Offutt also took over management of the grist- and sawmill.

The flatboat with Offutt, Lincoln and Johnston reached New Orleans in a month; John Hanks had disembarked at St. Louis. A month went by while the crew sold their stock and the boat and viewed the sights of New Orleans. Although not confirmed, it is said that Lincoln saw a slave auction and commented: "By God, boys, let's get away from this. If ever I get a chance to hit that thing, I'll hit it hard."[3] The men traveled by steamboat to St. Louis, where Offutt bought stock for the New Salem store and for its shipment to Beardstown, Illinois, at the junction of the Illinois and Sangamon Rivers. Meanwhile, Lincoln and Johnston walked to Coles County to visit their parents; near the end of July, Lincoln walked on to New Salem.[4]

Shortly after his return, on August 1, Lincoln voted for the first time, casting his ballot for James Turney for Congress, Bowling Green and Edmund Greer for justices of the peace and John Armstrong and Henry Sinco for constables. This was a good way for Lincoln to meet more of the inhabitants of New Salem and the entire Clary's Grove precinct and establish himself as a first-class raconteur.[5] During this time, the Offutt store was under construction; it opened sometime in September. It was about this time that William G. Greene was hired to be Lincoln's assistant, particularly in regard to checking on the credit standing and honesty of the customers.

A History of Lincoln's Alma Mater

The clerk of the Sangamon County commissioners court issued a license to Offutt on July 8, 1831, for which he paid five dollars.[6] There is some disagreement about when the store opened, but it was sometime in the month of September. It was located on the bluff opposite the mill below and near Clary's grocery. On September 2, Offutt was deeded the lot on which it was built (witnessed by Lincoln and William G. Greene), and allowing time for construction of the log building, it probably opened at mid-month.[7] Lincoln and Greene made the store their home, sleeping there at night and often taking their meals at the home of Bowling and Nancy Green a few miles outside New Salem.

Denton Offutt and others had noticed Lincoln's physical strength; the former was known repeatedly to talk about it. It wasn't long before Offutt told neighboring merchant William Clary that Lincoln could outperform any man in the vicinity, betting Clary ten dollars that this included out-wrestling anyone. Jack Armstrong, the reputed wrestling champion, was chosen to wrestle Lincoln. The match was set to take place on a patch of level ground near Offutt's store. The contest was described in a letter of July 30, 1865, from William Greene's brother Lynn McNulty Greene to William Herndon:

> *It was while selling goods for Offutt & soon after he had come there that Lincoln and Jack Armstrong had a wrestle for $10.00. Offutt & Bill Clay bet the money. Armstrong after Struggling a while with but a prospect of throwing Mr Lincoln broke his holts on & caught Mr Lincoln by the legs & they came to the ground. Clary claimed the money & said he would hav [sic] it or whip Lincoln and Offutt both. Offutt was inclined to yield as there was a score or more of the Clarys Grove Boys against him and Mr Lincoln & my brother W.G. Greene But Lincoln said they had not won the money & they should not have it & although he was opposed to fighting if nothing else would do them he would fight Armstrong, Clary or any of the set. So the money was drawn and from that day forward the Clary Grove Boys Were always his firm friends.*[8]

This was the start of a lifelong friendship between Jack and Hannah Armstrong and Abraham Lincoln.

In *Honor's Voice*, Douglas Wilson devotes an entire chapter to the wrestling match between Lincoln and Armstrong and the history on the frontier of these types of contests in general. There was no enmity between the contestants, and one did not provoke the other, so the match was not

"Armstrong after Struggling a while with but a prospect of throwing Mr Lincoln broke his holts on & caught Mr Lincoln by the legs & they came to the ground." *Painted by Harold von Schmidt for* Esquire *in 1949.*

considered a fight. Wrestling was a popular sport and, in particular, a test of one's strength and skill against an opponent.[9]

For the remainder of 1831, Lincoln continued his work at the Offutt store and became immersed in the quotidian life of a small pioneer village. He judged contests, spent hours in storytelling, witnessed and wrote documents for New Salem citizens and, sometime in the winter of 1831–32, joined the debating society started by James Rutledge. Of the documents he witnessed, the bond deed for James Eastep on November 12 is in Lincoln's handwriting.[10]

1832

Lincoln wanted to improve himself through education. In an 1858 autobiography for inclusion in the Dictionary of Congress, he wrote, "Education defective." A year later, in an autobiography composed for Jesse Fell, Lincoln described his formal education:

> *There were some schools, so called; but no qualification was ever required of a teacher beyond "readin, writin, and cipherin" to the Rule of Three. If a straggler supposed to understand latin happened to sojourn in the neighborhood, he was looked upon as a wizzard [sic]. There was absolutely nothing to excite ambition for education. Of course when I came of age I did not know much. Still somehow, I could read, write, and cipher to the Rule of Three; but that was all. I have not been to school since. The little advance I now have upon this store of education, I have picked up from time to time under the pressure of necessity.*[11]

He was a study in contrasts; he looked like a country bumpkin, but it was evident that he was well read. During his Indiana boyhood, he had read the Bible, Aesop's *Fables*, John Bunyan's *Pilgrim's Progress*, Daniel Defoe's *Robinson Crusoe*, Mason Weems's *The Life of Washington*, James Riley's *Narrative* and other works, including various textbooks.[12] In an interview with William H. Herndon sometime in 1865 or 1866, Lincoln's cousin John Hanks said: "Abraham read Constantly when he had an opportunity. Lincoln devoured all the books he could get or lay hands on: he was a Constant and voracious reader."[13] In an interview with Herndon on September 8, 1865, Lincoln's stepmother Sarah stated that "Abe read all the books he could lay his hands on—and when he came across a passage that Struck him he would write it down....He would then repeat it over to himself again & again....When it was fixed in his mind to suit him...he never lost that fact or his understanding of it."[14]

Robert B. Rutledge, a younger brother of Ann Rutledge, wrote to Herndon on November 30, 1866, with this observation of Lincoln at New Salem:

> *An opportunity would offer, he would apply himself to his studies, if it was but five minutes time, would open his book, which he always kept at hand, & study, close it recite to himself, then entertain company or wait on a Customer in the Store or post office apparently without any interruption, When passing from business to boarding house for meals, he could usually be seen with his book under his arm, or open in his hand reading as he walked.*[15]

Sometime in 1832, Lincoln contacted the local schoolteacher, Mentor Graham, and asked for an English grammar. He was told that a farmer, John Vance, living north of the village had a copy of *Kirkham's Grammar*. Lincoln

New Salem

The sixth edition (1828) of *Kirkham's Grammar*, used by Abraham Lincoln in his studies. Mentor Graham guided Lincoln through the book, helping him with difficult sections. *The Library of Congress.*

walked the distance out to Vance's farm and either borrowed or purchased the book. It is assumed that it was bought by Lincoln, because the book was never returned to Vance.

In a letter to William H. Herndon dated May 29, 1965, Mentor Graham wrote:

> *Mr Lincoln spoke to me one day and Said "I had a notion of studying grammar." I replied to him thus "If you Ever Expect to go before the public in any Capacity I think it is the best thing you can do."...I have taught in my life four or six thousand people as School Master and no one ever surpassed him in rapidly—quickly and well acquiring the rudiments & rules of English grammar.*[16]

Graham guided Lincoln through the book and often would help him with difficult sections. His friends, in particular William Greene, would ask questions from the grammar, and Lincoln would provide the answers or definitions. Next Lincoln took on mathematics and developed a mastery of Euclidean geometry. He also studied history and literature with encouragement from Jack Kelso.

On March 9, 1832, Abraham Lincoln announced his candidacy for the Illinois legislature in a written platform, published in the *Sangamo Journal*. In it he presented his views, among them being "the improvement of Sangamo[n] river, to be vastly important and highly desirable to the people of this county."[17] His peroration is worth the read:

> *Every man is said to have his peculiar ambition. Whether it be true or not, I can say for one that I have no other so great as that of being truly esteemed of my fellow men, by rendering myself worthy of their esteem. How far I shall succeed in gratifying this ambition, is yet to be developed. I am young and unknown to many of you. I was born and have ever remained in the most humble walks of life. I have no wealthy or popular relations to recommend me. My case is thrown exclusively upon the independent voters of this county, and if elected they will have conferred a favor upon me, for which I shall be unremitting in my labors to compensate. But if the good people in their wisdom shall see fit to keep me in the background, I have been too familiar with disappointments to be very much chagrined.*[18]

In mid-March, the steamboat *Talisman* left Beardstown to travel up the Sangamon River. Lincoln was one of several to board the vessel and help to clear brush, tree branches and other obstructions along the way. After steaming past New Salem, the vessel arrived at Portland on March 24. A ball was held in Springfield to celebrate this feat. A week later, with Rowan Herndon as pilot and Lincoln as his assistant, the trip downriver to Beardstown commenced. The trip was fraught with difficulties, since the water fell so low that part of the mill dam at New Salem had to be temporarily removed.[19]

By spring, Denton Offutt's store was closing, he himself would be leaving New Salem and Lincoln was soon to be unemployed. The year before, the Sauk and Fox tribes had been forcibly removed to lands west of the Mississippi, promising never to return east unless they had permission. On April 5, 1832, Chief Black Hawk and two thousand braves, old men, women, boys and younger children crossed over to Illinois, announcing

the peaceful intention of planting corn. However, they were armed and created a panic on the frontier.

On April 19, a proclamation from Illinois governor John Reynolds, issued on April 16, was posted in New Salem, calling up the militia and ordering them to Beardstown on April 22. There is some discrepancy in the historical records over the date Lincoln was elected captain of the Thirty-First Regiment of Illinois Militia. One source states that it happened on April 7,[20] and another source gives the date as April 21 at Richland (nine miles outside New Salem) on the Dallas Scott farm.[21] Nevertheless, on April 22, Lincoln's company was at Beardstown. It was here that Lincoln had a wrestling match with Lorenzo Dow Thomson to decide whether Lincoln's or Captain William Moore's company would have a particular campground. Lincoln lost the match in two falls. From April 23 to 28, Lincoln's company had light drills, drew supplies from the quartermaster, was officially enrolled in the service of the state and, on April 28, "received…for the use of the Sangamon County Company, under my command, thirty muskets, bayonets, screws and wipers, which I oblige myself to return on demand. A. Lincoln, Capt." This was in response to a report of the same day from the brigade inspector, who found "that thirty guns are wanting to arm the company completely."[22]

Abraham Lincoln's company enrolled a number of men from the New Salem community: Jack Armstrong was first sergeant; William F. Berry and Alexander Trent were corporals; and ten were privates—Hugh Armstrong, David Pantier, George Warburton, John M. Rutledge, William Clary, William G. Greene, Royal Clary, Pleasant Armstrong, David Rutledge and Isaac Guliher. At Beardstown, Lincoln's company was assigned to the Fourth Regiment of the Brigade of Mounted Volunteers commanded by General Samuel Whiteside.[23]

> *As their captain was drilling them one day with two platoons advancing toward a gate, he couldn't think of the order that would get them endwise, two by two, for passing through the gate. So he commanded, "This company is dismissed for two minutes, when it will fall in again on the other side of the gate."*[24]

Much of Abraham Lincoln's service in the Black Hawk War consisted of marching from one place to another. He was never involved in a firefight with Black Hawk's warriors. Lincoln related in later years that he "had a good many bloody struggles with the musquitoes [*sic*]."[25] It is worth noting that among the regular army officers in the war were a future president

of the United States (Zachary Taylor), future president of the Confederate States of America (Jefferson Davis), future Union officer who commanded Fort Sumter (Robert Anderson) and two future Confederate officers (Albert Sidney Johnston and Joseph E. Johnston).[26]

Between April 29 and May 14, the troops marched from one location to another in northwest Illinois. On May 14, Major Isaiah Stillman engaged in a battle with Indians near today's Byron, Illinois. During the conflict, the soldiers were routed, leaving twelve dead. The next day, Lincoln's company arrived at the site of the battle, finding the scalped and mangled remains of the soldiers, whom they buried on May 16. The company then returned to Dixon's Ferry. Between May 18 and 26, the troops were again on the march, arriving at Ottawa, where, on May 27, Lincoln's company was mustered out of service. He then enrolled in the company of Captain Elijah Iles for service in a twenty-day regiment. Lincoln was required to furnish his own arms and horse at a cost of $130.[27]

From early to mid-June 1832, Elijah Iles's company marched to Dixon's Ferry, Galena, back to Dixon's Ferry and on to Fort Wilbourn on the Illinois River. There, on June 16, the company was mustered out, and Lincoln reenlisted for thirty days as a private in Captain Jacob M. Early's company. After Early's company was mustered in on June 20, it left for Dixon's Ferry until it was sent to assist Major John Dement, who had fought an action against Black Hawk and a group of Sauk at Kellogg's Grove on June 25. The company arrived on June 26. Two days later, Early and his men returned to Dixon's Ferry. On July 1, Early's company entered what is now Wisconsin, where it was mustered out on July 10. They set out for Dixon's Ferry, and on the night before he was to leave for home, Lincoln's horse was stolen, along with that of George M. Harrison. It took the company a few days to travel to Peoria. Since Lincoln and Harrison were without mounts, they bought a canoe and spent two days paddling down the Illinois River to Havana, where they sold the canoe and walked to New Salem.[28]

After Lincoln's return to New Salem, and with only about two weeks until the election, he began to campaign for the legislature. In an enclosure to a January 23, 1866 letter from Abner Y. Ellis to William H. Herndon, Ellis writes of a speech Lincoln delivered at Pappsville to a crowd attending a sale. Ellis writes, "I have a copy of his first speech hear [*sic*] it is":

> *Gentlemen and fellow citizens I presume you all Know who I am*[.] *I am humble Abraham Lincoln*[.] *I have been solicited by many freinds* [sic] *to become a candidate for the Legislature. My politicks* [sic] *are short and*

New Salem

sweet like the old Woman[']s dance. I am in favor of a National bank. I am in favor of the internal improvement system and a high protective Tariff—These are my sentiments and political principles[.] [I]f Elected I shall be thankful if not it will be all the Same.[29]

After delivering his speech, Lincoln intervened in a fight involving one of his friends.[30]

Two days before the August 6 election, Lincoln and the other candidates were in Springfield and made closing campaign speeches. Lincoln lost his first election, coming in eighth out of thirteen candidates and receiving 657 votes. He fared very well in his own precinct, where he polled 277 out of 300 votes.

Lincoln's loss in the election also found him without employment. While he pondered his options, many of which did not seem to hold any promise, a series of events involving other New Salem residents eventually presented an opportunity for Lincoln. In the summer of 1832, James Herndon informed his brother Rowan of his wish to leave New Salem. They had opened a store in the village in 1831. James then sold his interest in the store to William F. Berry, a person with whom Rowan was reluctant to associate in business because of Berry's intemperate habits. So, in August, Rowan sold out his shares in the store to Lincoln, who then partnered with Berry. The store building that formally belonged to the Herndon brothers became the first Berry and Lincoln store, situated just west of Peter Lukins's residence. Years later, a nephew of James Rutledge spoke of the store to Ida Tarbell:

I have been in [the second] *Berry and Lincoln's store many a time. The building was a frame—one of the few frame buildings in New Salem.* [Actually, the only one.] *There were two rooms, and in the small back room they kept their whiskey. They had pretty much everything, except dry goods—sugar, coffee, some crockery, a few pairs of shoes (not many), some farming implements, and the like. Whiskey, of course, was a necessary part of their stock. I remember one transaction I had with them. I sold the firm a load of wheat, which they turned over to the mill.*[31]

Besides his new role as a merchant, Lincoln's activities for the remainder of 1832 included witnessing various transactions and clerking with William G. Greene at two elections. One of these elections, for local constable, was held at the residence of John McNamar on September 20—John Clary was the winner. The other election was held at the home of Samuel Hill on November 5 to select presidential electors. Lincoln voted for Henry Clay. At

this time, Lincoln also completed honorable discharge forms for men who served in his company in the Black Hawk War.[32]

1833

At Springfield on January 4, 1833, Lincoln received $125 for his services in the Black Hawk War. On January 15, Lincoln drew up a mortgage for William Greene Jr. to Reuben Radford. For some time, there had been bad feelings between Radford and the Clary's Grove boys, and the situation finally came to a head. While away, Radford left his store in charge of a nephew. After the Clary's Grove toughs were denied more than two drinks, they trashed the store. A dispirited and disgusted Radford announced that he would sell out to the first person with an offer. William Greene heard this and bought the store and stock for $400. That same day, he sold the stock to Berry and Lincoln for $750. The establishment became the second Berry and Lincoln store. The kinds of merchandise stocked in a store like the one now owned by Berry and Lincoln can best be described by an advertisement placed by Reuben Radford in the *Sangamo Journal* in January 1832:

> *Fresh Groceries*
> *Reuben Radford*
> *Has just received an extensive assortment of Groceries and other goods, among which are the following articles:*
> *Cogniac* [sic] *Brandy; Monongahela Whiskey; Pittsburg Whiskey; Peach Brandy; Molasses; Mackeral* [sic]*; Copal Varnish; Madeira Wine; Tenereffa do* [do possibly refers to muscovado, a partially refined or unrefined brown sugar in loaf form]*; Malaga do; Brown Sugar; Loaf do; Indigo; Madder; Powder; Pepper; Stoughton's Bitters; Shaving Soap; Imperial Tea, fresh and good; Melsee Segars* [cigars]*; Common do; Candy, assorted; Nutmegs; Pearl Ash; Shot; Bleaking; Pins; Chocolate; Chalk; Whiting; Tuck Combs; Fine do; Tumblers; Bed Cords; Ink Powder; Slate Pencils; New England Rum; Writing Paper; Crackers; Ink Stands; Snuff Boxes; Tobacco, of various kinds; Allspice; Coffee; Copperas* [iron sulfate for textile dyes or making ink]*; Alum; Shoe Blacking; Shoe Brushes; Sweet Oil; Raisins; together with almost every other article which makes up the assortment of a grocery store—all of which will be sold on good terms.*
> *Most articles of country produce will be received in payment for their goods.*[33]

Greene, not Berry and Lincoln, owned the building and lot. Berry and Lincoln paid $265 in cash and assumed the payment of two notes of $188.50, each payable to Radford. Greene received a horse, saddle and bridle from Berry for the balance.[34] In addition to his work in the store, Lincoln continued to act as amanuensis for his neighbors, drawing up or witnessing bills and other documents. He also served on juries and appeared as a witness at trials. Using a book of legal forms, Lincoln drafted legal instruments for people in and around New Salem.[35]

On February 4, Lincoln was one of several "inhabitants of the North West part of Sangamon County, being acquainted with the route of the road reviewed and located by the reviewers, in pursuance of an order of Court from Petersburg on Sangamon river [sic] to the county line in the direction of Bardstown, [who] hereby state that the said road as located by reviewers is a good and advantageous location and such as meets with our entire and unqualified approbation."[36] Other signers of the petition included Martin and Alexander Trent, Martin Waddell, Mentor Graham, Bennett Abell, Philemon Morris, James Pantier, Isaac Guliher, James and David Rutledge, Alexander Ferguson, David Whary and William Greene.

On March 6, the Sangamon County commissioners issued a one-year license to Berry and Lincoln to operate and maintain a tavern in New Salem, for which they paid $7. This meant that they could sell liquor by the drink at prescribed rates: twenty-five cents for one-half pint of wine or French brandy; eighteen and three-quarters cents for one-half pint of rum, peach brandy or Holland gin; twelve and a half cents for whiskey or domestic gin; and twelve cents for apple brandy. Berry signed his name and Lincoln's to the $300 bond, also signed by Bowling Green.[37] Having a license to sell liquor by the drink only exacerbated William Berry's alcoholism and led to Lincoln turning over his interest in the store to his partner on April 29, 1833. On May 7, he was appointed postmaster at New Salem by President Andrew Jackson. Lincoln had to post a $500 bond; this was signed by Nelson Alley and Alexander Ferguson. Lincoln remained postmaster until May 30, 1836, when the post office was removed to the new town of Petersburg.[38] On June 14, 1837, two months after moving to Springfield, Lincoln closed out his accounts from his time as postmaster. The Springfield postmaster William Carpenter recorded: "For Cash recd of A. Lincoln late P.M. New Salem $248.63."[39]

Lincoln's position of postmaster left him with considerable time for earning additional money by doing odd jobs for people in and around

New Salem. Sometime during 1833, he became deputy surveyor to John Calhoun; however, the first mention of a Lincoln survey is not until January 14, 1834. In preparation for this new role, Lincoln borrowed books from Calhoun and, with the help of Mentor Graham, learned the procedures, purchased a horse on credit and obtained surveying instruments. The books Lincoln used in his studies were *A System of Geometry and Trigonometry with a Treatise on Surveying* by Abel Flint (1804) and *The Theory and Practice of Surveying* by Robert Gibson (1814). Calhoun assigned the northern part of Sangamon County to Lincoln; his wages were determined per a scale put in place by the legislature in 1827.[40]

During the summer of 1833, Lincoln went to his first circus, held in Springfield. It featured an eighteen-foot-long anaconda and an act in which a young woman stood on the back of a horse and rode around the ring at full speed. This was the first time a circus and menagerie ever toured the West, and it attracted many families from the surrounding countryside.[41]

In 1833, Lincoln was deeply in debt. The following is a compilation of his indebtedness, the judgments against Lincoln and others associated with the debts and the resolution of the debts.

When the steamboat *Talisman* stopped at New Salem in 1832, local resident Nelson Alley (who for a time operated the former Rutledge tavern) purchased goods on credit from Vincent A. Bogue, the man who had chartered the boat. Bogue then assigned the note to the Sangamon County sheriff, James D. Henry. On October 30, 1832, Alley made a revised note to the sheriff for $104.87½ to be used to pay Bogue's creditors, endorsed by Lincoln. Alley defaulted, and a suit was brought in the circuit court of Sangamon County on August 10, 1833, against Alley and Lincoln. On September 13, a judgment was rendered against the defendants, and they were assessed damages of $107.31 plus $11.75 in costs to be paid in six installments.[42]

It was the convoluted financing of the Lincoln and Berry partnership ventures that resulted in the biggest debt issues for Abraham Lincoln. As mentioned earlier, James and Rowan Herndon sold their interests in their store to Berry and Lincoln, respectively. Reuben Radford, whose store had been vandalized by the Clary's Grove boys, sold the building and stock to William Greene for $400. He paid Radford $23 of the $400 and assumed notes of $188.50 each, using for collateral a mortgage on a lot in New Salem that was drawn up and witnessed by Lincoln.[43] Greene then sold the store and stock to Berry and Lincoln for $750. The latter paid $265 in cash and assumed the payment of the two notes of $188.50, each payable to Radford. Berry and Lincoln threw in a horse for good measure.

Greene's notes to Radford came due on October 19, 1833. Not having the full amount, Greene, Berry and Lincoln negotiated and signed a new note for $379.82 due to Radford by April 20, 1834.[44] Since Radford credited the three with $125, the remaining balance was reduced to $254.82. Meanwhile, Radford reassigned a portion of the notes to Peter van Bergen. In addition to the debts and actions related to the Radford transactions, on August 26 Alexander and Martin Trent sued David Rutledge, Greene and Lincoln over a bond conveyance they had signed on January 31 for $150.[45] The suit was dismissed on September 16, when each of the parties agreed to pay half.[46]

1834

On January 14, 1834, Lincoln conducted and wrote a description for his first survey. The work was done for Russell Godbey, a farmer who lived six miles north of New Salem.

> *Jany. 14 Surveyed for Russel Godby* [sic]—*the West half of the North quarter of Section 30 in Township 19 North of Range 6 West. Begining* [sic] *at a White oak 12 inches in diameter bearing N 34 E 84 Links a White oak 10 inches S 58 W. 98 Links. Thence South 40 chains to a White oak 12 inches. N 73 E. 20 Links. Thence East 20 chains to a Black oak 12 inches S 54 W. 16 Links. Thence North 40 chains to a Post & mound. Thence West 20 chains to the beginning.*
> *Chainmen*
>
> *J. Calhoun, S S C Hercules Demmin*
> *BY A. Lincoln*[47]

For this first surveying job, Lincoln was paid with two buckskins. He conducted another survey on February 13 and 14.

On March 1, a public political meeting of the New Salem citizens was held to nominate a candidate for governor. Bowling Green served as chairman and Lincoln acted as secretary. A committee of Dr. John Allen, Nelson Alley and Samuel Hill drafted a preamble and three resolutions expressing the wishes of those in attendance, which were adopted unanimously. They nominated General James D. Henry, former Sangamon County sheriff and Black Hawk War veteran and hero (he died four days later).[48] Two days after this meeting, Lincoln was busy with another survey.

Lincoln added to his debt when he purchased a horse on credit from William Watkins for $57.86. Lincoln failed to pay Watkins, who sued him. Lincoln and Berry (who had cosigned the note) appealed on April 26 and lost. They were ordered to pay $57.86 plus interest and costs. Previously, on April 7, Peter van Bergen had filed an action against Lincoln, Berry and Greene for $500 and $50 in damages. The court issued a summons for them to appear in court on April 29; however, only Greene was served, since Lincoln and Berry could not be found. Greene did not appear on April 29, and a judgment by default was awarded van Bergen for $204.82 and $18.42 in damages. Lincoln and Berry were required to show cause why they should not be included in the judgment (Lincoln was served with this writ on August 20).[49] In the midst of all of this, Lincoln announced his candidacy for the legislature, continued to work as deputy surveyor and postmaster at New Salem and, more than likely, attended political events. At an election for sheriff of Sangamon County held at the home of William F. Berry on May 5, 1834, Lincoln and Mentor Graham served as clerks of the election. The county commissioners court paid Lincoln $1 for his services.

An incident from 1834 that shows Lincoln's neighborliness and kindness toward others occurred in early June, somewhere on the road between New Salem and Springfield. A Dr. Charles C. Chandler laid claim to a quarter section of land not far from New Salem but had not yet registered it with the land office in Springfield. A short time after Chandler settled on the claim, a man named Henry Ingalls (surnamed "English" in earlier versions) arrived and intended to settle in the same area if he could find a suitable piece of land. The doctor assisted him in this endeavor, but Ingalls was not as satisfied with any land as much as he was with Chandler's claim, and the latter generously offered to let him have half of his own claim. Ingalls, while still not happy with the arrangement, stated that he would go to Springfield the next day and enter the eighty acres Chandler offered to him. He left Dr. Chandler and went to stay with another settler, but a friend of the doctor warned him that he overheard Ingalls declare his intention to enter the entire quarter section. Chandler needed to act quickly. He rode off and borrowed the needed money from a friend, and by the time he returned home to prepare for the trip to Springfield, his horse was already fatigued. Riding at night had to be undertaken at a slower pace. When Chandler was close to his destination, two men on horseback overtook him. One of them, Abraham Lincoln, seeing the tired state of the doctor's horse and learning of his plight, offered his own horse so that Chandler could arrive at the land office in time to enter his claim.

Dr. Chandler arrived before Ingalls and was able to secure title to the entire quarter section.[50]

On August 4, 1834, Abraham Lincoln was elected to the Illinois Ninth General Assembly, where he was to take his seat on December 1. He came in second with 1,376 votes cast out of a total of 8,569. In the intervening four months, at John T. Stuart's suggestion, Lincoln took up the study of law, borrowing books from Stuart and purchasing at an auction a copy of Sir William Blackstone's *Commentaries on the Laws of England*. He also studied a borrowed copy of Chitty's *Treatise on Pleading and Parties to Action*. Lincoln continued in his duties as postmaster and deputy surveyor. In the latter role, he was called on to survey and plat town sites. On September 30, he completed the site of New Boston, located on the Mississippi River.[51]

On October 27, Lincoln and Mentor Graham served as clerks of the election at the home of William F. Berry for the purpose of selecting representatives to Congress. Lincoln wrote out the returns, which were certified by Justice of the Peace Bowling Green.

On November 19, Lincoln and Berry were included in the April 29 judgment against William Greene. Lincoln was unable to pay the judgment, and the sheriff levied on his horse, saddle, bridle and surveying instruments, resulting in a loss of the major part of Lincoln's livelihood. These items were put up for auction, but Lincoln's friend James Short bid on them for $120 and returned them to Lincoln.[52]

Before leaving New Salem for Springfield to catch the stage, Lincoln borrowed $200 from local farmer Coleman Smoot to purchase a new suit of clothes.[53] On November 28, Lincoln left Springfield by stagecoach for the state capital, Vandalia (where a third statehouse was then being built), arriving sometime the following day. On December 1, he took his seat in the legislature. From that day through February 13, 1835, Lincoln was at Vandalia representing his district. Three days after taking his seat, Lincoln was appointed to the Committee on Public Accounts and Expenditures. On December 9, he introduced his first bill, which would limit the jurisdiction of justices of the peace.[54]

1835

William F. Berry died on January 10, 1835. The total of his estate was $60.87½, half of which was paid to the doctors.[55] Lincoln's salary as a state legislator was $3.00 per diem and $3.00 for each twenty miles traveled to

and from the capital. Beginning with the Tenth General Assembly, both salary and mileage were increased to $4.00, respectively.[56]

On January 24, Lincoln's first bill, limiting the jurisdiction of justices of the peace, passed 39–7.[57] On February 9, Lincoln voted yea on the Illinois and Michigan Canal bill, a significant piece of legislation for opening up navigation from the Great Lakes to New Orleans. It passed 40–12. The Ninth General Assembly adjourned on February 13, and Lincoln headed home to New Salem on February 14.[58] In the time between legislative sessions, Lincoln continued as postmaster and deputy surveyor, continued his study of law and also witnessed documents and engaged in political activities.

At an election for state senators held at the residence of Nelson Alley on August 3, Lincoln cast his votes for John Calhoun and Job Fletcher. He also voted for Thomas M. Neale for county surveyor over Reuben Harrison, who had done the original plat of New Salem in 1829.

On August 25, 1835, Ann Rutledge died of typhoid at the Rutledge farm in the Sand Ridge community. It is doubtful we will ever know the complete story of Abraham Lincoln and Ann Rutledge.

Ann, the daughter of James and Mary Ann Rutledge, became engaged to store owner John McNamar sometime in 1831 or 1832. A more complete version of this engagement and its aftermath is recounted in chapter 2, in McNamar's biographical sketch. Briefly stated, he left Illinois in the fall of 1832 to return east, gather his family and return with them to New Salem. His absence grew longer, and after an exchange of some correspondence between him and Ann, the letters ceased altogether. Ann's family and friends thought she had been wronged. Lincoln got to know Ann when he boarded at the Rutledge tavern for a time in 1832. According to residents of New Salem in reporting to William Herndon, Lincoln fell in love with and courted Ann Rutledge and eventually became engaged to her. The Rutledges moved to Sand Ridge in 1833, so it is assumed that Lincoln visited and courted her there.[59] When Ann died, it is said that Lincoln became gravely depressed and his friends feared for his sanity. During this period, he lived with Bowling and Nancy Green, who nursed him back to a healthier state. Lincoln appeared to be self-absorbed, at times neglecting his post office duties; but a month after Ann's death, he surveyed a ten-acre tract of timberland and during the remainder of the autumn immersed himself in the study of law and made preparations to return to the state legislature in December.

Was Lincoln's grief over the death of Ann Rutledge out of the ordinary? No. Throughout his life, Abraham Lincoln grieved deeply over the deaths of those with whom he had close relationships: his mother, Nancy, and

sister Sarah; Bowling Green, at whose funeral he was so overcome that he could not deliver his planned eulogy; his sons Eddy and Willie; Elmer Ellsworth, who had clerked in Lincoln's law office and upon whose death Lincoln ordered an honor guard to bring Ellsworth's body to the White House, where it lay in state in the East Room; and Edward D. Baker, after whom Lincoln named his son Eddy.

Ann Rutledge's name did not surface publicly until William H. Herndon's November 16, 1866 lecture at Springfield, Illinois: "A. Lincoln—Miss Ann Rutledge, New Salem—Pioneering, and the Poem called Immortality—or 'Oh! Why Should the Spirit of Mortal be Proud.'" The lecture covered the same information just summarized. Additionally, Herndon used the occasion to assail his former law partner's widow, Mary Todd Lincoln, claiming that after the death of Ann, Lincoln never loved another woman.[60] In a letter of December 24, 1866, a month after Herndon's lecture, artist Francis B. Carpenter initially chides Herndon:

> *At first, as I proudly wrote you, with Lincoln's family before me, your lecture while it intensely interested me, and explained much before mysterious about Mr Lincoln, seemed almost a rash drawing aside of the curtain which should enshroud some part of every man's life. It seemed to me that Mr Lincoln himself would have deprecated it—and yet after further reflection, I am satisfied the truth should be Known.*[61]

Persons who knew Lincoln at New Salem discussed the relationship between Lincoln and Ann in interviews conducted by Herndon and also in letters written to him. Hardin Bale (interview on May 29, 1865), William G. Greene (interview on May 30, 1865), his brother Lynn (letter of July 30, 1865) and Robert Rutledge, Ann's brother (letter of November 1, 1866), all speak of Lincoln's love for and engagement to Ann and his mental "derangement" after her death.[62] James McGrady Rutledge, Ann's cousin (interview in March 1887), stated the following:

> *What is your Name, Age, and Occupation*
> *James M Rutledge, Age 72 years Occupation Farmer*
> *Was you well acquainted with Ann Rutledge, and If related to her You may state what relationship Existed*
> *I am. We were first Cousins*

> *Do You Know any thing* [sic] *Concerning the Courtship and Engagement of Abraham Lincoln and Ann Rutledge. If so state fully Concerning the same*
>
> *Well I had an Opportunity to Know and I do Know the facts. Abraham Lincoln and Ann Rutledge were Engaged to be married. He came down and was with her during her last sickness and burial.*[63]

The following odd exchange appeared in an interview between William Herndon and Isaac Cogdal sometime in 1865 or 1866, recounting a conversation between Cogdal and Lincoln in his law office:

> *After we had spoken over old times—persons—Circumstances—in which he showed wonderful memory I then dare to ask him this question…Abe is it true that you fell in love with & courted Ann Rutledge….Lincoln said, it is true—true indeed I did. I have loved the name of Rutledge to this day. I have kept my mind on their movements ever since & love them dearly—said L*
>
> *Abe—Is it true…that you ran a little wild about the matter:*
>
> *I did really—I run off the track: it was my first. I loved the woman dearly & sacredly; she was a handsome girl—would have made a good loving wife—was natural & quite intellectual, though not highly Educated—I did honestly—& truly love the girl & think often—often of her now.*[64]

When, in 1906, William Randolph Hearst bought the site of New Salem, and when reconstruction of the village commenced in the 1930s, the Ann Rutledge story was revisited and reexamined by historians, with some of them embracing and embellishing the legend and others dismissing it.[65] The revisiting and reexaminations continue to this day. Again, it is doubtful we will ever know the complete story of Abraham Lincoln and Ann Rutledge. It will remain a farrago of fact and myth.

On December 7, Lincoln was in Vandalia for the opening session of the Ninth General Assembly, and the next day he was again appointed to the Committee on Public Accounts and Expenditures. During the session, Lincoln introduced one bill himself and otherwise participated in discussions and voted on a variety of other bills and issues, including the Illinois and Michigan Canal Act and the Beardstown and Sangamon Canal Act (Lincoln purchased stock in the latter). He also wrote the report for the committee on which he served.[66]

1836

On January 18, the legislature adjourned *sine die*, and Lincoln spent the next two days on his return journey to New Salem.[67] Lincoln continued to show an interest in the navigability of local rivers, both in the legislature and on the hustings. On February 13, he gave a speech to a gathering in which he promoted the Beardstown and Sangamon Canal (he had previously reported a bill in the legislature on the proposed waterway). And on February 27, he invested in stock in the canal.[68]

Starting in November 1835, Lincoln was retained to survey and plat the town of Petersburg, Illinois. Peter Lukins and George Warburton had begun the process in 1832 and even played a card game for naming rights to the town, but by 1833, they had sold the land to Hezekiah King and John Taylor. They are the ones who employed Lincoln to conduct the survey of the first sixty square blocks. Lincoln's work was interrupted by his return to the legislature and was resumed on his return from Vandalia. On February 17, Lincoln certified that the survey and plat were completed and correct.

Probably using part of his legislative salary, Lincoln purchased forty-seven acres of land from the federal government on March 16 for $1.25 per acre. The land was located on the Sangamon River, twelve miles north of New Salem and one mile east of the new town of Huron. Eight days later, he obtained his first property in Springfield, purchasing two lots—Nos. 6 and 8 in Block 1 on the north side of Jefferson Street between Sixth and Seventh Streets—from Thomas Edwards for $25 each.[69]

On March 18, Lincoln's horse was missing, and the *Sangamo Journal* carried the following announcement on March 26:

> *STRAYED OR STOLEN From a stable in Springfield, on Wednesday, 18th inst. A large bay horse, star in his forehead, plainly marked with harness; supposed to be eight years old; had been shod all round, but is believed to have lost some of his shoes, and trots and paces. Any person who will take up said horse, and leave information at the* Journal *office, or with the subscriber at New-salem* [sic] *shall be liberally paid for their trouble.*
>
> A. Lincoln[70]

On March 19, Lincoln announced in the *Sangamo Journal* that he was a candidate for the legislature. On March 24, he met the first of three steps

toward his license to practice law when the Sangamon Circuit Court entered his name as a person of good moral character.[71] Lincoln continued to be busy with his duties as deputy surveyor and platted the town sites for Huron, Albany and Bath, Illinois. He no longer had duties as postmaster at New Salem, since the post office there was discontinued on May 30, 1836.

On June 13, he laid out his political platform in a letter to the editor of the *Sangamo Journal*:

> *To the Editor of the* Journal:
> *In your paper last Saturday, I see a communication over the signature of "Many Voters," in which the candidates who are announced in the* Journal *are called upon to "show their hands." Agreed. Here's mine!*
>
> *I go for all sharing the privileges of the government, who assist in bearing its burthens. Consequently I go for admitting all whites to the right of suffrage, who pay taxes or bear arms, (by no means excluding females.)*
>
> *If elected, I shall consider the whole people of Sangamon my constituents, as well as those that oppose, as those that support me.*
>
> *While acting as their representative, I shall be governed by their will on all subjects upon which I have the means of knowing what their will is, and upon all others, I shall do what my own judgment teaches me will best advance their interests. Whether elected or not, I go for distributing the proceeds of the sales of the public lands to the several states, to enable our state, in common with others, to dig canals and construct rail roads, without borrowing money and paying interest on it.*
>
> *If alive on the first Monday in November, I shall vote for Hugh L. White for President. Very respectfully,*
>
> <div align="right">*A. Lincoln.*[72]</div>

He spent the weeks of July 4 through 30 attending many political gatherings, where he gave speeches taking the Whig position on issues and engaged in a debate in Springfield on July 11.

On August 1, he was elected to the Tenth General Assembly, receiving the most votes (1,716 out of 18,279) of the seventeen candidates for the legislature. On September 9, Lincoln was granted a license to practice law in the state of Illinois, and on October 3, he was present at the opening of the fall term of the Sangamon County Circuit Court. Two days later, he filed a plea in *Hawthorn v. Wooldridge*. The jury trial was held on October 8, and Lincoln lost the case in one of the actions; the other two actions continued and were not finally litigated until March 14, 1837.[73]

On November 7, at the home of Caleb Carman, an election was held to select electors to vote for a president and vice president of the United States. Lincoln cast his votes for Hugh L. White's electors.

The opening session of the Tenth General Assembly was held on December 5, 1836; on December 10, Lincoln was appointed to the Committee on Finance and the Penitentiary Committee.[74] It was during this session that significant decisions were made to divide the northern half of Sangamon County into a separate county (which had major implications for New Salem) and to move the state capital from Vandalia to Springfield (in which Lincoln, as a member of the Long Nine, played a significant role). The session also took up an internal improvements plan for railroad and canal construction and for improving rivers. The legislators from Sangamon County were known for their height (averaging over six feet, with an average weight over two hundred pounds, hence the appellation "Long Nine"). They were pushing for the relocation of the state capital to Springfield and were willing to use any quid pro quo of votes for other members' favorite projects to effect this end.

From December 21 to 23, introduction of a bill for a new county carved out of the northern half of Sangamon County was followed by discussion and amendments to the bill.[75] On December 21, Lincoln delivered a speech on the bill to create the new county.[76] (It was not until February 15, 1839, that the Illinois legislature created Menard County and made Petersburg the county seat. As stated earlier, this, when added to the fact that the post office was moved from New Salem to Petersburg on May 30, 1836, sealed New Salem's fate.)

1837

On January 23, discussion began on the internal improvements bill, which passed in the house 61–25 on January 31. The bill was rejected by a council, but it was passed by the senate on February 23 and again by the house two days later. Clarifications to the act were passed on March 2.[77]

Kaskaskia was the capital of the Illinois Territory from 1809 until statehood was granted in 1818. It then served as the first state capital until 1819, when it was moved to Vandalia. A capitol building was constructed at Vandalia in 1824; this was the structure in which Abraham Lincoln served during most of his time in the legislature. Lincoln was one of a group of legislators from central Illinois who wanted to see the capital

relocated to Springfield. After the Ninth General Assembly recessed in 1836, the people of Vandalia tore down the old capitol and replaced it with a new and larger building. When the Tenth General Assembly convened on December 5, the legislators from central Illinois saw the new structure but were not deterred in their efforts to relocate the state capital to Springfield. On February 11, they initiated the process, but those opposed repeatedly took steps to have the bill tabled. After continued discussion for the proposed state capital site, on February 28 on the fourth ballot, Springfield received the most votes. (The first meeting of the legislature at Springfield was not until December 9, 1839.)[78]

On March 1, Lincoln was admitted to the bar for the state of Illinois. On March 3, he and Dan Stone, a Whig lawyer from Springfield, entered and signed, as "Representative from the county of Sangamon," a protest on slavery. The men stated their belief "that the institution of slavery is founded on both injustice and bad policy; but that the promulgation of abolition doctrines tends rather to increase than to abate its evils." The house adjourned *sine die* on March 6. Lincoln spent the next two days returning to New Salem. After his return, Lincoln was engaged in the practice of law, often with John T. Stuart.[79]

On April 12, an announcement appeared in the *Sangamo Journal* (shown in the image below).

Lincoln, realizing that he needed a change in order to establish himself as an attorney at law and to advance in politics, left New Salem and moved to Springfield, Illinois, on April 15.

On April 12, 1837, this announcement appeared in the *Sangamo Journal*. Lincoln left New Salem and moved to Springfield, Illinois, on April 15. *Courtesy Seth Kaller, Inc. Historic Documents.*

New Salem

> *One morning Lincoln saddled a horse borrowed from Bowling Green, threw across its back saddlebags containing his copies of Blackstone and a change of underwear, and started on the twenty-mile ride to Springfield....Lincoln pulled in his horse at the general store of Joshua Speed. He asked the price of bedclothes for a single bedstead, which Speed figured at $17.00. "Cheap as it is, I have not the money to pay," he told Speed. "But if you will credit me until Christmas, and my experiment as a lawyer here is a success, I will pay you then. If I fail in that I will probably never pay you at all." Speed said afterward: "The tone of his voice was so melancholy that I felt for him. I looked up at him and thought that I never saw so gloomy and melancholy a face in my life." Speed offered to share his own big double bed upstairs over the store. Lincoln took his saddlebags upstairs, came down with his face lit up and said, "Well, Speed, I'm moved."*[80]

Abraham Lincoln lived at New Salem for six years after arriving a "strange[r], friendless, uneducated, penniless boy, working on a flatboat—at ten dollars per month."[81] It was his first home away from his parents. However, he was not without ambition. As William Herndon observed: "His ambition was a little engine that knew no rest."

Between June 1858 and June 1860, he complied with three requests for autobiographies. One was from Charles Lanman. Another request came from Jesse Fell, to whom Lincoln wrote, "There is not much of it, for the reason, I suppose, that there is not much of me." A third came from John L. Scripps, who was composing a campaign biography for the 1860 election. Here is how Lincoln described his New Salem years to each of them, the third of which he prepared in the third person:

> *Profession, a lawyer.*
> *Have been a captain of volunteers in Black Hawk war.*
> *Postmaster at a very small office.*[82]

> *Then I got to New-Salem (at that time in Sangamon, now in Menard County), where I remained a year as a sort of Clerk in a store. Then came the Black-Hawk war; and I was elected a Captain of Volunteers—a success which gave me more pleasure than any I have had since. I went the campaign, was elated, ran for the Legislature the same year (1832) and was beaten—the only time I ever have been beaten by the people. The next, and three succeeding biennial elections, I was elected to the Legislature.*

I was not a candidate afterwards. During this Legislative period I had studied law, and removed to Springfield to practice it.[83]

A. [sic] stopped indefinitely, and, for the first time, as it were, by himself at New Salem....This was in July, 1831. Here he rapidly made acquaintances and friends. In less than a year Offutt's business was failing—had almost failed—when the Black Hawk war of 1832 broke out. A. [sic] joined a volunteer company, and, to his own surprise, was elected captain of it. He says he has not since had any success in life which gave him so much satisfaction. He went to the campaign, served near three months, met the ordinary hardships of such an expedition, but was in no battle....Returning from the campaign, and encouraged by his great popularity among his immediate neighbors, he the same year ran for the legislature, and was beaten....This was the only time A. [sic] was ever beaten on a direct vote of the people. He was now without means and out of business, but was anxious to remain with his friends who had treated him with so much generosity, especially as he had nothing elsewhere to go to. He studied what he should do—thought of learning the blacksmith trade—thought of trying to study law—rather thought he could not succeed at that without a better education. Before long, strangely enough, a man offered to sell, and did sell, to A. [sic] and another as poor as himself, an old stock of goods, upon credit. They opened as merchants; and he says that was the store. Of course they did nothing but get deeper and deeper in debt. He was appointed postmaster at New Salem—the office being too insignificant to make his politics an objection. The store winked out. The surveyor of Sangamon offered to depute to A. [sic] that portion of his work which was within his part of the county. He accepted, procured a compass and chain, studied Flint and Gibson a little, and went at it. This procured bread, and kept soul and body together. The election of 1834 came, and he was then elected to the legislature by the highest vote cast for any candidate. Major John T. Stuart, then in full practice of the law, was also elected. During the canvass, in a private conversation he encouraged A. [to] study law. After the election he borrowed books of Stuart, took them home with him, and went at it in good earnest. He studied with nobody. He still mixed in the surveying to pay board and clothing bills. When the legislature met, the law books were dropped, but were taken up again at the end of the session....In the autumn of 1836 he obtained a law license, and on April 15, 1837, removed to Springfield, and commenced the practice—his old friend Stuart taking him into partnership. March 3, 1837.[84]

New Salem

Outside and to the left of the entrance to the visitors' center and museum at today's New Salem there is a statue by Avard Fairbanks, *The Resolute Lincoln*, depicting him with an axe in one hand and a book in the other. The sculpture speaks volumes about how Lincoln's New Salem years shaped him from a person with limited education and prospects into the statesman he became. He developed into a leader in the small village and surrounding areas and at the state level. He acquired an education in English grammar and mathematics, learned the art of surveying and read Shakespeare, Burns and other authors of literature and history. He studied law, was licensed to practice in the legal profession and was admitted to the bar. He improved in his ability to express himself verbally and in writing, became more analytical in his thinking and, with his knack for storytelling and making friends, became a first-rate politician. He was a merchant, served a brief stint as a soldier during the Black Hawk War and had his first experiences in elective politics when he was elected to the state legislature in 1834 and 1836, having lost in his first attempt in 1832.

Benjamin Thomas also mentions Lincoln's lack of formal schooling when he came to New Salem and how he learned from discussions with and observations of the people around him. For the first time in his life, Lincoln was earning a living with his mind instead of through manual labor. The residents of New Salem had an influence in the shaping of the later Lincoln; he knew the common people because he came from them.[85]

However, he did not accomplish all of this in a vacuum. The people who befriended the "strange, friendless, uneducated, penniless boy, working on a flatboat—at ten dollars per month" were critical to the shaping of Abraham Lincoln. Fern Nance Pond, in answering the question "Why a State Park at New Salem?" writes:

> *But it is also important to know how Abraham Lincoln lived from the time he himself became a citizen of the village of New Salem in 1831, until six years later when he left New Salem for Springfield to become a practicing attorney. Deep impressions were made upon the mind and character of the young man by his experiences, his environment and his New Salem neighbors during those formative years.*[86]

When he first arrived at New Salem and during his tenure there, Lincoln was housed and fed often through the kindness of the Onstots, Greens, Armstrongs, Grahams, Burners, Rowan Herndon, Abells and others, albeit

sometimes in exchange for odd jobs that Lincoln performed for them. Mentor Graham guided and tutored him in his studies, and his friend Billy Greene quizzed him on the contents of *Kirkham's Grammar*. Jack Kelso read and recited Shakespeare and Burns and loaned these volumes to Lincoln. Others loaned books to him, including his future law partner, John T. Stuart, who encouraged Lincoln to study law. Hannah Armstrong washed and mended his clothes, once using an animal pelt Lincoln received in payment for a survey to "fox" his trousers as a protection against briars. When, as has been reported by former residents of New Salem, Lincoln was distraught in the late summer of 1835, Bowling and Nancy Green took him into their home and nursed him back to health.

The memories of Lincoln collected by William H. Herndon in interviews with and letters from persons who knew him at New Salem tell of the qualities that Lincoln already possessed and further developed while he resided in the village. In a letter from Quincy on May 28, 1865, Rowan Herndon recalled: "He was the favorite of them all at home Men & women & Childern [sic]....During his stay at my house my family Became much attached to him he was always at home wherever he went very Kind to the Widoes [sic] & olfins [orphans]."[87] In an interview at Petersburg on May 29, 1865, Mentor Graham said of Lincoln: "I wish to say one or two words about his Character. It was this—he was a very simple open souled man: he was a sincere man—a man of purpous [sic]—was frank—ingenuous: he was kind, humerous [sic] and deeply honest—never deviating from the Exact truth: he was studious....Mr Lincoln's character at once seized observation and that only led to a respect—love & confidence in Abraham Lincoln."[88] William G. Greene, in an interview by Herndon dated May 30, 1865, said: "Mr Lincoln, in Conclusion, was a man of kindness—Courtesy—sincerity & honor, having a mind of great force & depth....He grasped the Peoples [sic] affections through simplicity of his good nature—his honesty—his integrity—his virtue—his high moral & noble qualities."[89]

The residents of New Salem accepted and befriended Lincoln, provided him with employment opportunities, encouraged him in his ambitions to succeed, helped to educate him, honored him with their trust and votes and tended to his needs. In the 1925 biography *The Life of Abraham Lincoln*, William E. Barton wrote: "New Salem has been rightly called Lincoln's Alma Mater."[90] In remembering Abraham Lincoln, these people should not be overlooked or forgotten. And that is why "the short and simple annals" of New Salem's residents and the location and care of their known final resting places are important.

6

"SALEM, INDEED, IS DESOLATE": THE SITE AFTER 1840

Around 1839 or 1840, New Salem, which had been founded in 1829, ceased to exist. It had served as a commercial center for the surrounding countryside and had a post office. The town of Petersburg, surveyed and laid out in 1836, was viewed as more accessible than New Salem, and many residents of the latter packed up their belongings and moved to the new town, which then became the new commercial center. Many even disassembled their residences and business structures and moved them to Petersburg, where they were reassembled. When the post office was moved from New Salem to Petersburg on May 30, 1836, New Salem's fate was sealed. As Springfield to the south continued to grow, particularly after it became the state capital, the reach of New Salem's trading area was further diminished.

In March 1832, an attempt had been made to demonstrate that the Sangamon River was navigable when the steamboat *Talisman* traveled from Beardstown to Portland, just five miles north of Springfield. The navigability of the Sangamon was important to towns along that waterway, and Lincoln even discussed in detail the improvements of the river in his platform as a candidate for the Illinois legislature. It took eleven days for the *Talisman* to complete the journey, as volunteers had to break through ice and clear other obstructions along the way. In 1836, another steamboat, the *Utility*, steamed up the Sangamon and, because the river level was falling, got stuck on the milldam at New Salem. It could not be refloated and was dismantled and sold. It was clear to the people in the area that New Salem could not be a river town, prompting more people to quit the village.

A History of Lincoln's Alma Mater

On February 15, 1839, the Illinois legislature created Menard County by separating the northern half of Sangamon County because of the increased population in that area. Petersburg was selected as the new county seat. To the few remaining residents of New Salem, this sounded the death knell of the town. They left the village to relocate to places with brighter prospects.

By 1840, a number of houses and stores had been left on the site to disintegrate or had been moved to Petersburg or other locations. Only ten structures remained, among them the following: the Camron, Dr. John Allen and Herndon houses; the Hill residence and store; and the carding mill and wool house. Over time, the cellars of the removed or rotted buildings filled with debris. The same year, one of the descendants of William Clary, Louisa, pointed out the former site of what she called the Hill Tavern (where the Hill residence once stood). By 1845, only two structures remained, one of which was the Camron home occupied by Jacob Bale, who had secured the deed to the site of New Salem in 1841. A traveler "on the road from Petersburg, Illinois, May 4, 1847," visited the site and noted:

> *Salem, indeed, is desolate. Once upon a time it was a busy, thriving place. It is (or was) situated upon a high bluff, overlooking the Sangamon River and the country for some distance around. What rollicking times were there some ten years ago? It is said that a horse race came off regularly every Saturday afternoon—a drinking spree followed, perhaps a fight or so, and at night those disposed took a turn at old sledge or poker. But the glories of Salem have departed.—Most of those whilom engaged in the "joust and tournament" there, have left the "diggings." Petersburgh [sic] has been built up on a pleasant site; a few miles below.*[1]

> *It was once a bustling town. It was the place where all trade centered. I well remember when it was in its glory. It was over a half mile long. The main street ran from the mill west to Miller's blacksmith shop on the right hand with Onstot's cooper shop on the left, with Dr. Allen's field of twenty acres at the west end of town, and a little farther on was Mentor Graham's brick house, with forty acres cleared out of the barrens. There was only one street running east and west, except where the Springfield road turned south from the log hotel. The Hill's and Bale's carding machine and Hill's store, with Lincoln's and Green's [sic] and McNamar's and Offit's [sic] stores, formed a nucleus around which trade centered, while Waddle's [sic] hatter shop, Johnson's [sic]*

wheelright [sic] *shop and Alex Fergesson's* [sic] *shoe shop, made a nice little humming town.*

*It was the only town, till Petersburg began to grow, between Havana and Springfield.*²

By 1860, nothing much remained. The hilltop site was known as Old Salem.

After the election of Abraham Lincoln as president of the United States, there was new interest in the site. Following his assassination, biographers, including William Herndon and Ida Tarbell, visited the location. Historians and biographers wished to learn more about Lincoln's early years. Locals had picnics on the grounds where New Salem once stood. Herndon and Weik, in *Abraham Lincoln: The True Story of a Great Life*, wrote:

*This once sprightly and thriving village is no longer in existence. Not a building, scarcely a stone, is left to mark the place where it once stood. To reach it now the traveler must ascend a bluff a hundred feet above the general level of the surrounding country....A few crumbling stones here and there are all that attest its former existence. "How it vanished," observes one writer, "like a mist in the morning, to what distant places its inhabitants dispersed, and what became of the abodes they left behind, shall be questions for the local historian."*³

The 1874 *Atlas Map of Menard County* included an image of what was purported to be the decaying remains of the Rutledge tavern, but it was actually the John Camron house. In the 1879 *History of Menard and Mason Counties, Illinois*, there is a statement concerning the Camron residence:

The cabin of John Cameron [sic] *long remained as a monument to the memory of Salem. Until a few months ago it stood in desolate solitude, but lately it has fallen down and has been removed, and there is nothing now to mark the locality of this first town in the limits of Menard County, save the scattered debris, barely indicating that buildings of some character once stood there.*⁴

The Menard Old Settlers Association was organized in 1870, and its members recounted tales of the village and its residents, including Lincoln. In the late 1870s, the mill ceased operation (it burned down sometime in the 1880s). By 1875, tourists were climbing the road to the site to see the former location of the Offutt store, where Lincoln was first employed at New Salem. There were three trees growing out of the cellar of the long-gone building;

"Salem, indeed, is desolate." This photo was taken of the abandoned site of New Salem by visitors in the 1890s. *From Thomas P. Reep,* Lincoln and New Salem.

visitors cut them into pieces to carry off as souvenirs. They also saw the ruins of the old milldam and depressions in the ground that were the remains of other cellars. An 1879 description of the milldam stated:

> *At the foot of the bluff, just at the brink of the water, stands an old water-mill* [the Bale Mill that replaced the original], *a broken dam*

stretches across the stream, and through its countless chinks and crevices the water murmurs, making sad music to the seeming desolation, which seems to reign all around, for there is not a building of any kind, save the old mill, nearer than a fourth of a mile to the old town site.[5]

Parthena Hill, the widow of New Salem merchant and entrepreneur Samuel Hill, was still living in 1880 and produced a map of New Salem showing the location of the buildings. In 1884, William G. Greene accompanied a reporter for the *Chicago Tribune* and pointed out where the various houses and stores once stood. The *Tribune* correspondent wrote:

I write from a town without a post office, a tavern or shop. There is not a house in sight....I came here today with a few old settlers as on a pilgrimage....We drove up from Petersburg about two miles, passing on the way [the] *site of the old mill, run by Lincoln and the remains of the old dam on which his flat-boat lodged when floating down from Sangamontown* [sic] *on the way to New Orleans.*

After much debate as to the mode of reaching the old site, we entered an old field through a gate, and driving up a hill showing a wheel track through tall weeds, we rode over the streets of the old town. The weeds were as high as the horses' backs. "Right here was Denton Offit's [sic] *store where Lincoln and I clerked together." Mr. Green* [sic] *had not been here for forty years, yet recognized the spot. A small depression showed a former cellar. Out of it grew three trees about 50 feet high, making one in their outline. There was a locust thorn, with boughs interlaced like a fine fringe, an elm and a cottonwood.*

At one time there were three stores here, and a church serving as a school house. Now all is desolate. Petersburg...took the wind out of its sails. It was abandoned for a short time. The roof-tree moulded on the crumbling wall. Then all disappeared, and only a few holes are left to show where the houses and stores once were.[6]

Ida Tarbell visited the site in the 1890s and also interviewed locals in preparation for articles she was writing for *McClure's* magazine and for her subsequent book *The Early Life of Abraham Lincoln*. J. McCan Davis prepared a map of the site, and a photographer who accompanied Tarbell recorded a series of images, among them the desolate hilltop; the three intertwined trees growing out of the Offutt store cellar, with a portrait of Lincoln chiseled high on the trunk of one of them; and the remains of Bowling Green's house, where Lincoln had stayed (then being used as a stable).

A History of Lincoln's Alma Mater

Above: In the 1890s, Petersburg photographer C.S. McCullough photographed a number of sites in and around New Salem, including the remains of Bowling Green's home. *From C.S. McCullough,* Petersburg and the Early Home of Abraham Lincoln, Artistic and Poetic.

Right: Three intertwined trees were growing out of the site of the Denton Offutt store cellar. A portrait of Lincoln was chiseled high on the trunk of one of them. *From C.S. McCullough,* Petersburg and the Early Home of Abraham Lincoln, Artistic and Poetic.

In the 1890s, C.S. McCullough photographed a number of sites in and around New Salem, including what was purported to be the second Berry and Lincoln store attached to the rear of L.W. Bishop's gun shop in Petersburg. According to Ida Tarbell, it was purchased in the 1830s by Bishop's father and placed next to his house to be used as the gun shop. When it was moved to Petersburg's public square and Bishop built a new shop, the Berry and Lincoln building was squeezed into the backyard, where it was standing when McCullough photographed it. It was reported that the building was intact except for the original back room.[7] In *Record of the Restoration of New Salem*, Joseph Booton wrote:

> *It will be noted that this structure is 12 feet by 18 feet and the foundation of the Berry and Lincoln store measures 20 feet by 20 feet. If this was the original Berry and Lincoln store, then it was dismantled and the material brought to Petersburg and rebuilt. The new structure built of the original materials was made smaller in size. If the structure was moved from New Salem to Petersburg (which seems unlikely) it seems improbable that this was the Berry and Lincoln Store.*[8]

Writing in 1902, T.G. Onstot recorded:

> *The destruction of the mill and dam has been complete. I supposed the dam was fixed for all time and that after the mill had been burned that the dam would stand for a thousand years, and that the water would spurt through the rocks till Gabriel should sound his trumpet. The dam was built of stone in cribs made of timber, and more than 1,000 loads of stones were filled in them. Where all the stone has gone is a mystery, and now, like Jerusalem, not one stone is left on another.*[9]

Local attorney and eventual charter member of the Old Salem Lincoln League Thomas Reep visited the site sometime in the 1890s with a view to writing an article for a literacy society publication. He had also visited the site a number of times during his boyhood. Former residents of the village and surrounding areas (William G. Greene and Uncle Johnny Watkins) toured the site with him, and Reep developed a deep interest in New Salem and the location of its buildings.[10] In 1918, he published *Lincoln and New Salem*. Joseph Booton, the chief draftsman for the Illinois Department of Public Works and Buildings, later interviewed Reep about the visit, and his comments were quoted extensively in *Record of the Restoration of New Salem*.[11]

A History of Lincoln's Alma Mater

In the interview, Reep recalled his visit to the site with Greene and Watkins:

> *We went around to the southeast corner and went in the gate and drove up, slanting up the hill toward the north, a little west of north, got up near the top of the hill, unhitched our horse from the buggy, tied him to a tree there....I remember distinctly that there was a lot of what looked like the remains of an old chimney, the lower part of an old chimney, and a whole lot of bricks scattered around there. The grass was high, there hadn't been anything done to it.*[12]

A popular educational and recreational event in isolated rural areas of late nineteenth-century America was the Chautauqua assembly, or Chautauqua, which provided entertainment and education in a camp-like setting through lectures, concerts and plays. The name came from Chautauqua Lake in New York, where the first such assemblies were held. In 1898, the Old Salem Cumberland Presbyterian State Chautauqua Association held an assembly near the site of New Salem. Attendees visited the location and roamed the grounds on which the village once stood.[13] In 1909, the association purchased fifty-four acres of land on the Sangamon River one-half mile from the site of New Salem, where pioneer artifacts were displayed and from which a steamboat took visitors to the site, where they could walk about the grounds.[14]

On August 17, 1906, William Randolph Hearst delivered an address to the Old Salem Chautauqua Association assembly. He bought the site for $11,000 and deeded it in trust to the association.[15] In 1909, the association announced plans to restore the village as it was in the 1830s. Reverdy J. Onstot, aided by other people who remembered New Salem, drew up a map that helped to locate where the original buildings had stood.[16] Nothing came of the plans until the formation of the Old Salem Lincoln League in January 1917, which held its first meeting on February 1. In the intervening years, attendance at the Chautauquas had diminished, and a typhoid contamination of the wells in 1915 resulted in the cancellation of the 1916 event.[17] One of the league's goals was to have the site of New Salem declared a state park. An Independence Day picnic was held by the league that same year, attended by many of the old settlers who had visited the village in the 1830s. They helped to locate the sites of the long-gone buildings, and a committee for that purpose chaired by Thomas P. Reep marked the location of the old road and each structure. Nevertheless, the memories of the early settlers were often conflicting. When the original 1829 survey and plat done by Reuben S. Harrison was found, the work progressed.[18]

7
RECONSTRUCTION PHASES

In 1918, the women of the Old Salem Lincoln League were scouring the surrounding countryside for family heirlooms and artifacts, including furniture and utilitarian and decorative household items, from the period when New Salem existed. In the summer, the league also constructed a roadway to the site to accommodate travelers who visited. It was completed in time for the raising of the first five structures on July 30.[1]

The year 1918 was the centennial of the state of Illinois. To celebrate this anniversary, Menard County put together a pageant with scenes from the history of the village to be performed on September 2 and 3 at New Salem. In the September 1 edition of the *Springfield Sunday Journal*, a heading read "Pageant to Start Monday," followed by:

> *Perhaps the greatest spectacle ever planned in the county will be given Monday and Tuesday afternoon out on New Salem hill, one mile south of the city of Petersburg. It is to be Menard county's* [sic] *Centennial celebration in the form of a pageant and called "The Lincoln Pageant of Salem Hill."*
>
> *It will be given under the auspices of the Old Salem League of this city, the organization that has done so much in the preserving of the name and works of Lincoln here in the community where he lived for seven years.*[2]

The article ended with a description of the pageant and a list of names of the descendants of the original residents they were portraying. The event

A History of Lincoln's Alma Mater

This is the 1918 reconstruction of the Rutledge tavern. The original tavern was sold when James Rutledge and his family moved to the nearby Sand Ridge community in 1833. *Illinois Regional Archives Depository, University of Illinois at Springfield.*

This is the 1918 reconstruction of the Denton Offutt store, where Lincoln worked as a clerk when he came to New Salem in August 1831. *Illinois Regional Archives Depository, University of Illinois at Springfield.*

was rained out, but it occurred instead on September 6 and 7. The *Petersburg Democrat—Extra* of September 13, 1918, reported on the "Revivification of New Salem, Abraham Lincoln's Home, 1831–37" with full coverage of the pageant, act by act and scene by scene.[3]

87

New Salem

The 1918 reconstruction of the Dr. John Allen residence is seen in its early stages, before the "chinking" of the logs. *Illinois Regional Archives Depository, University of Illinois at Springfield.*

The 1918 reconstruction of the store where Samuel Hill and John McNamar (McNeil) were in business until the partnership was dissolved on September 4, 1832. *Illinois Regional Archives Depository, University of Illinois at Springfield.*

On February 1, 1919, the State of Illinois granted state park status to the partially reconstructed village, and on April 3, Governor Frank Lowden signed the bill naming it Old Salem State Park.[4] The state's involvement provided for additional funding to reconstruct the village and the construction of a limestone building in 1921 to serve as a museum and home for an on-site custodian (today's Lincoln League store).

A History of Lincoln's Alma Mater

The work of reconstruction continued sporadically. When cooper Henry Onstot left New Salem in 1840, he removed his house and his shop to Petersburg, where he re-erected both on Main Street. The latter remained there until 1922, when it was purchased by the Old Salem Lincoln League and moved to its original site at New Salem the following year. Its clapboard siding was removed during restoration.

In 1923, the league also purchased land on which the school had once stood and where there was a cemetery. (Known today as New Salem Cemetery, it contains nine graves, six of which have markers.) In 1925, the state purchased this land from the league. Funding was awarded in July 1932 to continue reconstruction of the village, and on November 17, a cornerstone ceremony was held for what would be the second Berry and Lincoln store.[5] Shortly after that, on December 20, 1932, the site was renamed New Salem State Park.

Chief draftsman Joseph F. Booton of the Department of Public Works and Buildings designed the specifications for the reconstructed buildings. The 1918 Lincoln League cabins, constructed of cottonwood, had become desiccated and warped in the intervening years and had to be totally

Among the helpers on house-raising day, July 30, 1918, were six individuals who personally knew Lincoln and the ancestors of others who knew him. *From Thomas P. Reep,* Lincoln and New Salem.

New Salem

The Rutledge tavern was one of the buildings reconstructed on house-raising day, July 30, 1918. This view looks to the northeast. *From Thomas P. Reep,* Lincoln and New Salem.

replaced.[6] In order to determine where to locate the buildings, Booton overlaid the 1829 town plat onto one of the current site and used visible remnants of what had been the original road or main street. The original plat had forty-six numbered lots in four quadrants on both sides of the main street that shifted direction to follow the land contours. To confound matters, the lot numbers were repeated.[7] Booton also re-surveyed and platted the village based on all of the available evidence—books; letters and interviews of former residents, visitors and descendants of same; interviews of persons who had conducted previous excavations at the site; archaeological evidence from excavated cellars; and maps drawn by former residents and others to determine the location of each building. There was, however, little evidence on the appearance of the original buildings. In the case of the Henry Onstot residence, the dimensions of the excavated cellar were compared to those of the original house, which was still extant in Petersburg. More recent archaeological work has confirmed the accuracy of Booton's survey, except for an error in the location of the main street at the western end of the village. According to a *Report on Resurvey of Old Salem (Formerly New Salem)* done between August 29 and September 10, 1932, by Ray V. Tilly of Wood, Walraven, & Tilly, Civil Engineers of Springfield, Illinois:

A History of Lincoln's Alma Mater

This view, looking to the northeast, shows the Denton Offutt store under reconstruction on house-raising day, July 30, 1918. *From Thomas P. Reep,* Lincoln and New Salem.

The Onstot cooper shop was removed to Petersburg and remained there until 1922, when it was moved to its original site at New Salem. *Abraham Lincoln Presidential Library and Museum.*

The writer attempted by actual survey and by computation to reestablish the old village from the Instruments of Record here listed but found that several of serious magnitude existed in each. [A]lso found that Main Street, First Survey bears N. 84°-31' W. with the north line of said quarter section taken as east and west and that Main Street, Second Survey bears S. 82°-29' W. as the directions of said streets are defined by old building sites. The difference between the bearing of Main Street, First Survey and Main Street, Second Survey was found to be 13° as recorded but the bearing of each was found to be 7°-31' in a clockwise direction from the given on the recorded plat which would indicate quite definitely that magnetic bearings were used in the original survey of the village since the writer found his variation to be 4°-35' in his resurvey which would correspond to about 7°-30' in 1832, there having been 3° of variation in a counterclockwise direction during the past hundred years.[8]

Also, it appeared that eighteen of the twenty-two reconstructed buildings were erected on the archaeological remains of their original counterparts, although Booton replaced earth-walled cellars with limestone for sturdier foundations.[9] Richard S. Taylor and Mark L. Johnson state that "Booton equated authenticity with verisimilitude, an appearance of being real or true to the original that would enable visitors to experience the past by visualizing and immersing themselves in it."[10]

In January 1933, the first thirteen of what would be twenty-three buildings were under construction under general contractors English Brothers of Champaign, Illinois: Dr. John Allen residence, second Berry-Lincoln store, Clary's grocery, Samuel Hill residence, Hill-McNamar store, Robert Johnson residence, Peter Lukins residence, Miller and Kelso residence, Denton Offutt store, Henry Onstot residence, Dr. Francis Regnier office, Martin Waddell residence and Rutledge tavern.[11] Meanwhile, the collecting of family heirlooms and artifacts continued so that each of the reconstructed buildings would reflect the lives and occupations of its residents. The work began and continued under the administrations of Governors Louis L. Emmerson and Henry Horner, the latter a known Lincoln collector and expert whose collection is now part of the Abraham Lincoln Presidential Library and Museum.

Joseph Booton took into consideration several factors in the planning and construction of the reconstructed buildings at New Salem. Several accounts were available concerning the types of building techniques used in the 1830s. Among them was *The History of Menard and Mason Counties, Illinois* (1879):

The house was, in almost every case, built of logs, the cracks filled with pieces of wood called "chinks," and then daubed over with mortar made of clay. If the floor was anything more than the earth tramped hard and smooth, it was made of "puncheons," that is, logs split open and the split side turned upward.... The roof was made by drawing in the top after the manner of a boy's quail-trap, and laying on these "clapboards," as they were called by the Western people, but known among Yankees as "shakes." These being three or four feet in length, were held in place by logs laid on them, instead of nails. These were called weight-poles. For a fire-place, the logs were cut out of one wall of the room, for a space of five or six feet, and three sides were built up of logs, making an offset in the wall. This was lined with dirt, or stone if it could be had. The flue or upper part of the chimney was built of small sticks, plastered over with mud, mixed with grass or straw to hold it together. This was called "cat-and-clay" chimney. The door was also an aperture made by cutting out the logs in one side of the room; and the shutter was composed of a rude framer with clapboards nailed or pinned across. The hinges were also of wood, while the fastening consisted of a wooden latch catching on a hook of the same material. [This was before the use of wrought-iron hardware manufactured by the local blacksmith.] *To enable the occupants to open the door from the outside, a buckskin string was tied to the latch-bar, and passed through a small hole two or three inches above, so that when the string was pulled from the outside it lifted the latch out of the hook, and the door opened without further trouble. At night, or in times of danger, when they wished to lock the door, all that was necessary was to draw the string in through the hole, and all was safe. This is thus minutely described in order that the young people may understand the saying so common among the old people, when speaking of their hospitality, that, "the latch-string hangs out."*[12]

The settlers had migrated from other areas, most notably Kentucky and Indiana, and were experienced in erecting log cabins; therefore, their workmanship was somewhat advanced. This was evident in the adzed and notched-end oak or walnut timbers used in the reconstructions. Whereas, in the 1830s, the logs were "chinked" with sticks and a mixture of mud or lime mortar mixed with animal hair, the replica buildings were chinked with a modern type of mortar.[13] Early settlers cut and prepared the logs for the walls and other timbers for sills, jambs, rafters and floors. When these tasks were completed, neighbors gathered and helped with the house raising.

New Salem

Original stone-filled, wooden cribs that were part of the original milldam. They were excavated during reconstruction of the saw- and gristmill. *Abraham Lincoln Presidential Library and Museum.*

The New Salem residents also had access to the sawmill erected by Camron and Rutledge, and George Warburton built the only frame, clapboard-sided building in the village—later the second Berry-Lincoln store. The fireplaces in some instances were of mud-chinked logs and sticks; in others, stone and brick were used. Excavations revealed that the original structures had been set on stone piers, and similar techniques were used for the new foundations. The gable ends of the cabins were enclosed with vertical sawn planks, and the roofs were covered in wood clapboards or shakes. Windows for the reconstruction were of glass, although oiled paper and thinly stretched animal skins were probably also used in the 1830s. However, glass shipped north from St. Louis or Springfield was available to the early settlers. The windows are generally fixed, since they were meant to be used for ambient light rather than for ventilation.[14]

Since the 1830s buildings had basements, primarily used as cold cellars, the reconstructions had either interior trapdoors for access or external entrances. The cabin floors were made of puncheons—split logs smoothed by an adze on one side—or of sawn planks. Doors were constructed of boards cleated or nailed or pinned in place. While doors could be latched with a simple board-and-string mechanism, the presence of a blacksmith at New Salem would mean that some residences and businesses also had wrought-iron hinges, latches, et cetera.[15]

Features of the first thirteen reconstructions were based on the dimensions of the excavated cellars and other disturbances in the soil that indicated the presence of a lean-to shed or other type of addition. The number of interior rooms, if not known from other sources, was based on the living space required for the size of the family that resided in the original buildings and whether a business operated at the same sites. Whether a structure had a front porch or not was based on the means of the original owner, and in the case of stores, they were not originally part of the 1932 reconstructions. However, porches have since been added to some of the buildings, for example, the second Berry-Lincoln store.

"Research Field Notes" compiled in September 1935 by John J. Briggs for project superintendent David A. Kendall describe some of the early findings. On June 13 of that year, attempts were made to locate Henry Onstot's first home and cooperage on lot 11-S, but no traces were found. In July, work at the location of the Herndon brothers' residence found brick, stone pillars that supported the original structure, broken china, charcoal and an old axe-head, but no traces of a cellar. From the prevalence of flagstones, it was assumed that the Herndons had a floor made of those instead of from the

usual puncheons. Two wells were also located, one two hundred feet west of the Offutt store site and another fifty feet west of the Lukins residence. In trying to locate the Isaac Burner residence, few traces were found, probably due to hillside erosion behind the site.[16]

The residence of Dr. John Allen was built as a three-room house, resting on six piers and with a sixteen- by fourteen-foot basement under the largest room. During the 1918 excavation, the four corners of the foundation for the second Berry-Lincoln store were discovered intact, revealing a twenty-foot-square dimension for the building. The reconstruction was built with two rooms, the larger in the front and a smaller shed room in the rear.[17] Since Clary's grocery served the original community primarily as a tavern and gathering space, it was assumed to be more crudely built, and the reconstructed store reflects that.[18]

Based on the 1918 initial excavation, Samuel Hill's residence was reconstructed as a fourteen- by twenty-four-foot, two-story house with two rooms on the first floor: a fourteen- by sixteen-foot living/dining room and a fourteen- by eight-foot storage/utility space. The second story was designed with two bedrooms. The Hill-McNamar store was reconstructed as a fourteen- by sixteen-foot building set onto six piers. The original was purchased by Hill at Clary's Grove and moved to New Salem, where it stood until Hill moved it to Petersburg.[19]

The residences of Robert Johnston, Peter Lukins' and Martin Waddell are based on excavations of the basements and on what is known of their family details. There was no trace of the Miller and Kelso residence, and excavations revealed that there was no basement. The reconstruction was based on what was known of other double homes of the New Salem era. It was designed as two houses with a floored open area between them, all of which was covered by a common roof. Excavations at the site of the original Onstot cooperage provided the dimensions for the fourteen- by sixteen-foot reconstructed building. When Henry Onstot moved from New Salem, he dismantled his cooper shop and home and rebuilt them in the new town of Petersburg. The design of the reconstructed house was based on excavations of the original cellar and the dimensions of the original house. Dr. Francis Regnier's office was reconstructed as an eighteen- by twenty-three-foot cabin based on excavations of the original basement and foundation stones.[20]

The Rutledge tavern was reconstructed with a first floor and a loft. The former included a larger east room to serve as a combination kitchen, dining room and guest sitting room. A smaller west room was designed as a family sitting room and bedroom. Two lean-to additions, which on

the original may have been added by the tavern's second owner, Nelson Alley, were reconstructed on the west as an additional family bedroom and, on the east, as a summer kitchen or storeroom. The loft was built as a bedroom for men, including the Rutledge sons. In rebuilding the Rutledge tavern, no traces of the original tavern footings were found during excavations.[21]

In *Pioneers of Menard and Mason Counties*, T.G. Onstot described the original two-story log tavern:

> *It was built in 1830 by James Rutledge, and kept by him till 1833, when Henry Onstot, my father, became landlord for two years. It was the stopping place for travel from the east through Havana and the western part of the state. It was 16x30, with an ell 16x20, and was two stories high....After father moved out Nelson Altig* [Alley] *kept it for some time, and the last landlord before it was torn down was Michael Keltner.*[22]

On Sunday, October 15, 1933, the *Illinois State Journal* carried a story, "New Salem to Be Dedicated on October 26."[23] Details of the planned dedication were reported in the *Illinois State Journal* of Wednesday, October 25. For that event, Robert Kingery of the Department of Public Works and Buildings was seeking old-time wagons, coaches, carts and other pioneer vehicles for display on New Salem's main street. The dedication, set for the next day, was to be officiated by Governor Henry Horner. Official photos of the reconstructed site were taken by the Herbert Georg Studio of Springfield, and a sixty-five-page souvenir booklet containing a catalogue of items contained in the reconstructed buildings was available to those in attendance. Descendants of original New Salem residents would serve as hosts and hostesses at each building. Among these were John and Susana Onstot, grandchildren of Henry Onstot; Nelson Greene, grandson of William G. Greene; Abigail K. Bancroft, granddaughter of Dr. John Allen; Lula Hill Martin, granddaughter of Samuel and Parthena Hill; Caroline Armstrong, daughter-in-law of Jack and Hannah Armstrong; Mary Graham Bradley, granddaughter of Mentor Graham; and a number of relatives of the James Rutledge family, including Emma Rutledge Houghton, Harriet Rutledge Park and Edith Clary Worthington.[24]

In the story "Dedicate Restored New Salem Village Where Lincoln Lived," the *Illinois State Journal* of October 27 reported on the downpour of rain that accompanied the dedication ceremonies. In his dedicatory

remarks, Governor Horner stated that the rain "was but a frame from which the bright sunlight of Abraham Lincoln came shining through."[25]

In *Record of the Restoration of New Salem*, Joseph Booton discussed the controversy over the location of the original and the reconstructed Rutledge tavern. In a section entitled "The House by the Well," he wrote:

> *Up to the present time it has been generally assumed that the "House by the Well" labeled the "Rutledge Tavern" was originally built by James Rutledge and later purchased and occupied by Jacob Bale. However, some believe that this house was never the Rutledge Tavern at any time; that the tavern was farther north and slightly to the west, more or less across the street from Dr. John Allen's residence.*[26]

He presented two theories on the "House by the Well," along with supporting evidence that the building was erected either by James Rutledge or Jacob Bale. On the basis of the discussions, Booton concluded that the Rutledge tavern and the Bale house, as depicted in the 1874 Menard County atlas as the last structure standing at New Salem, were one and the same, in spite of reservations expressed by Ida Bale, who had visited the Jacob Bale home in her youth.[27] A map drawn for William H. Herndon depicts the Rutledge and Bale houses as two separate dwellings, and the latter is labeled "still standing."[28] The 1902 T.G. Onstot map in *Pioneers of Menard and Mason Counties* shows the Jacob Bale house (No. 2) and the Log (Rutledge) tavern (No. 4) as two separate structures.[29] "Jacob's house was the last to be moved away. The well still stands. It was walled with rock and is now covered with old railroad ties, and is in a good state of preservation, and is called 'Jacob's Well.'"[30]

In 1994, Robert Mazrim examined documents on the first excavations at New Salem and discovered two photographs taken in the summer of 1936, when the CCC reconstruction project was underway. The excavated cellar in one of the images indicated that it was on Lot 5, consistent with maps prepared by the villagers and others and with recorded deeds. This area today has no building on it; instead, it is used as a pasture for the horses kept at the reconstructed village. Therefore, the current Rutledge tavern is located south of the site of the original. Furthermore, when James Rutledge moved from New Salem to Sand Ridge, he sold the tavern to Nelson Alley. A recorded deed shows that he purchased from Rutledge Lot 5, directly across from the second Berry-Lincoln store.

A History of Lincoln's Alma Mater

This image of an original New Salem structure, drawn in 1874, mistakenly labels the Rutledge tavern. In actuality, this is the John Camron residence, later owned by Jacob Bale. *From* Illustrated Atlas Map of Menard County, Illinois. *n.p.: W.R. Brink, 1874.*

Maps by residents and others also placed the Rutledge tavern directly across from the aforementioned store.[31] A map of New Salem, drawn in 1866 for Petersburg county clerk Hamilton, with the assistance of George Spears and including a narrative description, also shows the "log hotel" next to the road and the Jacob Bale (John Camron) residence as a separate structure.[32]

When the Old Salem Lincoln League reconstructed the Rutledge tavern in 1918, it placed it to the south on Lot 6 where the remains of another log structure, a well and a root cellar had been found. These were, in actuality, the ruins of the Camron-Bale house. The same site was used for the 1930s reconstruction.[33] In his September 2, 1935 field notes, John J. Briggs recorded, "The only research locations not covered to date are the Camron residence, which would be in the shrubbery east of the Museum and extremely difficult to locate."[34] It would seem, therefore, that no attempt was actually made to locate and reconstruct the Camron residence, thus continuing the conflation between the Rutledge tavern and the Jacob Bale residence in the historical record of New Salem.

In 1997, Robert Mazrim asked the New Salem Lincoln League if he could re-excavate Lot 5. During the project, the bottom of the Rutledge

tavern cellar was discovered and found to contain various artifacts. The maps, records, memories and the archaeological record were all in accord with the original location of the Rutledge tavern.[35]

In the autumn of 1828, Reverend John Camron and James Rutledge, co-founders of New Salem, and their families settled on land entered on the bluff overlooking the west bank of the Sangamon River. There they built log homes. Oddly enough, the current reconstruction of New Salem does not have a Camron residence, and yet Camron was a founder of New Salem and actually owned the land on which the village was platted. James Rutledge, a relative and partner of Camron, was given but was never required to purchase the lot on which he built his residence.[36] There is, however, a reconstruction of the Rutledge residence/tavern. At the time of the 1930s reconstruction of New Salem, it was reported that the Bales had purchased the Rutledge tavern building in 1840 and had it moved to a farm for use as a corncrib.[37] The possibility exists that the association of Ann Rutledge and Abraham Lincoln and their purported romance may have helped continue the conflation of the last structure standing at New Salem (the Camron-Bale residence) with the Rutledge tavern and became part of the reasoning that went into the restoration decisions.

The final phase in the reconstruction of New Salem occurred in 1934, when a Civilian Conservation Corps (CCC) camp was established at the site. The CCC was a public works relief program for unemployed, unmarried men from relief families as part of President Franklin D. Roosevelt's New Deal. The CCC provided unskilled manual labor jobs related to the conservation and development of natural resources during the Great Depression. In the case of New Salem, these workers also planted trees; in reality, the original village that Lincoln experienced would have been denuded of trees, which were felled to build the original 1830s structures.[38]

The men also built rail fences, performed other landscaping duties and constructed the open-air Kelso Hollow Theater, where the New Salem story was once reenacted each summer. One of the last reconstructions was of the saw- and gristmill. Excavation of the original site uncovered parts of the original. When the CCC workers left in 1941, the remaining nine buildings had been erected, and what became known as the Wagon Wheel Inn at the foot of the road leading up the hill to the village was also built. (The Onstot cooperage, the only original structure from the 1830s, is not included in the count of the reconstructed buildings.)[39]

During the time the CCC was involved, work continued on gathering items with which to furnish and equip the cabins. A catalogue of these

Civilian Conservation Corps workers felling logs and using adzes to shape them for use in reconstructing New Salem residences and businesses. *Abraham Lincoln Presidential Library and Museum.*

CCC workers planted trees; in reality, the original village would have been denuded of trees, which were felled to build the original 1830s structures. *Abraham Lincoln Presidential Library and Museum.*

artifacts was prepared and printed by the State of Illinois Department of Public Works and Buildings in several editions over the years. The catalogue listed the many items that were donated, along with the history of each and the names of the donors. Some of the items were actually used or sold at New Salem. The descriptions that follow are all from the 1940 edition of the catalogue.[40]

The Henry Onstot house has a spindle-back, wood-bottomed straight chair originally owned by the Onstots that may have been used in the Rutledge tavern when the cooper owned that business. The Onstot Cooper shop displays a barrel made at the shop in 1835. The Martin Waddell residence has his original tanner's kettle located outside the building and a reed basket that had been used by a Mrs. William Pollock when she came into New Salem to shop. Dr. Francis Regnier's office contains a trunk, two wooden benches, a sign and a bootjack originally owned by the doctor. The Peter Lukins–Alexander Ferguson residence displays a child's shoe made by the cobbler Ferguson for the six-year-old son of Captain A.D. Wright, Richard Douglas Wright, and a Bible previously owned by the Jacob Bale family when they lived in the Camron house in the mid-1800s.

The Samuel Hill residence contains several items originally owned by Parthena Nance Hill: two blanket chests made in Kentucky and brought to Illinois when the Nances settled near New Salem; a wood footstool; three chairs; a pair of tongs; a hammer; a solid cherry chest of drawers; a walnut, zinc-lined washstand; a pewter teapot; a rifle; a large brown earthen jar with two ears; a sewing basket purchased at the Hill-McNamar store; a lantern; an "English Version of the Polyglot Bible" published in 1833 in Concord, New Hampshire; "Union Questions on Select Portions of the Scripture," published in 1831 in Philadelphia; two square bread plates, eight saucers, a China teapot, a sugar and creamer and three cups, all with a sprig pattern supposedly brought to New Salem from Beardstown by Abraham Lincoln; a mahogany-colored gravy boat, gravy ladle and tray in white floral design; a holly-patterned, oriental-style Staffordshire blue dish; and a Staffordshire pie plate with a Chinese pagoda design. Items originally owned by Samuel Hill include the following: two handmade gun hooks; a maple writing cabinet; "Brief History of Reform in Germany," published in 1832 in Boston by Putnam & Damrell, Publishers; and ovals.

The residence of Dr. John Allen has a number of items originally owned by the doctor, including a pewter castor with four glass bottles; a glass-footed spoon holder with hexagonal panels; concave discs; ovals; and a white teacup, white oval pickle dish and white large-footed tureen and lid on

A History of Lincoln's Alma Mater

This image was taken after the first thirteen of the twenty-two final reconstructions were completed, with the Onstot residence and cooper shop in the right foreground. *Abraham Lincoln Presidential Library and Museum.*

an eight-sided base, all with a raised design of grapes. The Denton Offutt store has items originally purchased there: a fiddle-shaped blown bottle or whiskey flask and a dinner plate that was one of a set of six purchased by Mrs. Washington Hornbuckle.

The Rutledge tavern has an item that was used by the Bales when they owned and lived at the former Camron house: a sadiron heater, which was placed on the coals and held the heating irons. The millstones from the original gristmill are also on display in the museum at New Salem.

In the early 1950s, Ralph Newman, then founder and proprietor of the Abraham Lincoln Book Shop in Chicago, brought to light a series of paintings done in the 1870s by Aaron Francis Phillips. Phillips, a native of Petersburg, Illinois, was born in 1848 and died from tuberculosis in 1899. His primary occupation was raising chickens; his art seems to have been an avocation. He had heard stories of Lincoln from his stepfather and Petersburg resident Dr. Richard E. Bennett. After Phillips's death, the paintings remained in the possession of the artist's family until Newman discovered them. They appeared in the February 15, 1954 issue of *Life* magazine and included portraits of both the original Rutledge-Camron and the 1850 Bale mills on the Sangamon River, a side view of the Samuel Hill residence, the Hill-McNeil store, the artist's self-portrait painted in 1882 and the three trees growing out of the cellar of what had been

the Offutt store. Concerning the latter, it is alleged that Phillips carved a portrait of Lincoln high up on the trunk of one of the trees.[41] Ida Tarbell included a photograph of the intertwined locus, elm and sycamore trees in her *Early Life of Abraham Lincoln*. The image shows the carving, and part of the caption reads: "High up on the sycamore some genius has chiselled [sic] the face of Lincoln."[42] In November 1979, Sotheby's of New York City sold the twenty-seven- by seventy-inch oil on canvas of the *First Rutledge-Camron Mill on Sangamon River* for $1,100.

8
NEW SALEM TODAY

In 1985, the name of the park was changed to Lincoln's New Salem State Historic Site. Under the Department of Conservation, it had been known as New Salem State Park, but "Lincoln" was added to clarify the site's status as a historic one and to serve as a reminder that Abraham Lincoln is at the core of the mission. In 1992, a new combination visitors' center/museum/theater complex was opened.

The New Salem Lincoln League, established in 1981, is a nonprofit organization whose mission is to preserve and maintain the village and to raise funds for this purpose. It also sponsors a series of annual events and demonstrations, lectures, workshops and other activities to inform visitors about life at New Salem in the 1830s. The league operates a museum store located in the reconstructed village in a stone structure that originally served as the museum and custodian's residence. A number of volunteer opportunities are offered and coordinated by the site to interested persons.

New Salem State Historic Site is open during posted hours, and visitors are free to walk through the village on their own. On special occasions and during regular operating hours, docents garbed in period dress are available to explain village life in the 1830s and to demonstrate various occupational and domestic activities. The number of docents and demonstrations varies with the availability of the volunteers.

The visitors' center includes a museum exhibit arranged chronologically on two levels, a land model of the park and an auditorium showing an orientation film about the site and its history. The museum displays a number

of original artifacts, such as Lincoln's surveying equipment and items used by the original New Salem pioneers. This facility is also used for lectures, concerts and plays. Outside and next to the visitors' center is the five-hundred-seat Kelso Hollow Theater, where various "Theatre in the Park" productions are offered each year, including dramas, musicals and concerts. Near the courtyard of the visitors' center are sculptures depicting Lincoln during the time of his life when he resided at New Salem: Avard Fairbanks's *Resolute Lincoln* and John McClarey's *Lincoln the Surveyor*. Near the entrance to New Salem, on Route 97, is Anna Hyatt Huntington's equestrian statue *Abraham Lincoln on the Prairie*.

Between March and October, Lincoln's New Salem State Historic Site features weekend demonstrations of a number of activities that represent village life in the 1830s, including blacksmithing, candle- and soap-making, cooking, coopering, gardening and weaving. Additionally, there are events for Boy Scouts, shows featuring antique farm equipment, music and other festivals, the annual candlelight tour on the first weekend in October, a fall festival later that month and, throughout the seasons, other activities as well.

A unique opportunity for youth is available in the Pioneer Life Summer Day Camp experience, one for children in grades four through six and another for students in grades seven through nine. Here they learn about and participate in home-related tasks and the various trades present in the village. The capstone experience is dressing in period clothing and engaging in village activities or as one of the docent/interpreters.

For the truly adventurous, a visit to the New Salem Cemetery (aka Bale Cemetery) is possible, but it involves a hike down a moderately difficult three-fourth-mile trail known as "Mentor Graham's Footsteps." There are ten recorded burials in the little cemetery, for which there are only six extant stones. The original location of Mentor Graham's schoolhouse was near this cemetery.

What follows is a brief summary for each of the twenty-four locations in the reconstructed village, along with the names and trades of those who occupied the buildings. In some instances, the owner's trade was conducted in a part of the residence and not in a separate building.

Henry Onstot Residence: The Onstot family first lived in a house at the east end of New Salem and then lived at and ran the Rutledge tavern. They did not move to this location until 1835. They left in 1840 and relocated to Petersburg. In 1846, they moved to Mason County and later to Forest City, Illinois.

Henry Onstot Cooper Shop: The only original building from New Salem, it is where Henry Onstot plied his trade as the village cooper.

Trent Brothers Residence: Alexander and Martin Trent arrived at New Salem in 1832 and built a house that was occupied jointly by their families. When William Clary left for Texas in 1833, the Trents took over operation of Clary's store and the ferry on the Sangamon River.

Joshua A. Miller and John "Jack" H. Kelso Residence: Miller and Kelso and their spouses (the Millers also had children) lived in what was known as a "dogtrot house," a double structure with an open area between the two houses. Both men left New Salem in 1836, Miller to a nearby farm and Kelso somewhere west.

Joshua Miller Blacksmith Shop: On many days when New Salem State Historic Site is open to visitors, a blacksmith is at the forge making various iron implements of the type used in the original village in the 1830s.

Martin Waddell Residence: Martin Waddell and his family arrived in 1832 and erected their home; they moved away in 1838. He was a hatter by trade and produced various styles of headwear made from rabbit and raccoon skins and also from felt.

Schoolhouse and Church: The schoolhouse, also used as a church, was originally located south of New Salem near the cemetery below a bluff south of Green's Rocky Branch.

Isaac Guliher Residence: Isaac Guliher was married to Elizabeth Burner, the daughter of Isaac Burner. They lived in New Salem from 1832 until their move to Knox County, Illinois, in 1834.

Robert Johnston Residence: Robert Johnston was a wheelwright and cabinetmaker who arrived with his family in 1832. The date when they left and their destination are unknown, but it is believed that they departed sometime between 1836 and 1840.

Isaac Burner Residence: Isaac and Susan Burner were two of the first settlers at New Salem, arriving in 1829. For a time, Burner operated a stillhouse in the village. They left in 1835 and moved near Knoxville, Illinois.

New Salem Carding Mill and Wool House: New Salem entrepreneur Samuel Hill opened a carding mill and wool house in the spring of 1835. It was later sold to Hardin Bale, who eventually moved the building and machinery to Petersburg.

First Berry-Lincoln Store: This building was first erected and owned by the Herndon brothers, James and Rowan, when they came to New Salem in 1831. It was later operated by Lincoln and William Berry, who, in 1832, moved into a larger store building.

New Salem

Dr. Francis Regnier Office: The building was originally erected in 1831 by early settler Henry Sinco and purchased by Dr. Regnier in 1832. He continued to maintain this office for his medical practice even after he moved, first to Clary's Grove and later to Petersburg.

Lukins-Ferguson Residence: Peter Lukins, a cobbler and repairer of leather goods, erected his home and business in 1831, but he left with George Warburton a year later to found and establish the city of Petersburg. Another leather worker, Alexander Ferguson, purchased the property and worked at New Salem until 1840, when he moved to a nearby farm.

Samuel Hill Residence: Samuel Hill was another of the early settlers at New Salem, arriving in 1829. He started a store and built the only two-story residence in the village. He moved with his wife and son to Petersburg in 1839.

Dr. John Allen Residence: James Pantier (discussed in chapter 2) purchased the first lots in New Salem, but he never built on them. Dr. John Allen bought the lots from Pantier in 1831 and constructed a house. He eventually moved to Petersburg, where he continued his practice.

Hill-McNeil Store: Samuel Hill operated a store in partnership with John McNamar (aka McNeil). The partnership lasted for only eight months. McNamar left New Salem to return east to collect his family and bring them back to the village. He did not return until 1835; he left again in 1837 and continued to live in the area.

Second Berry-Lincoln Store: John McNamar constructed the first store at New Salem in 1829 on this site. It is the only building that is framed and covered with clapboard instead of having the usual log construction. (For the story of Lincoln's involvement with the store and its failure, see chapter 5.) The original structure was moved to Petersburg in 1837.

Rutledge Tavern: James Rutledge, a co-founder of New Salem with Reverend John Camron, erected a home in 1828, which he converted into a tavern. When the Rutledges moved to the Sand Ridge community in 1833, the tavern was operated by Nelson Alley, Henry Onstot, Michael Keltner and Jacob Bale, who purchased it in 1837. For a discussion about the location of the reconstructed Rutledge tavern, its original and present locations and its conflation with the Camron-Bale residence, see chapter 7. After the death of James Rutledge in late 1835, the family moved for a time to Fulton County, Illinois. James's widow, Mary Ann, eventually moved to Birmingham, Iowa, in 1837 or 1839.

John Rowan Herndon Residence: Rowan Herndon and his brother James came to New Salem in 1831 and built a residence and store (the

present reconstructed first Berry-Lincoln store). James moved to Columbus, Illinois, in 1832. After the tragic death of his wife in 1833, Rowan moved to Island Grove and later to Columbus, Illinois.

DENTON OFFUTT STORE: Denton Offutt opened his store in 1831, but he left New Salem in 1832. He later made a name for himself as a "horse whisperer."

WILLIAM CLARY STORE: William Clary was one of the first merchants at New Salem. He left the village in 1833 and moved to Texas, first to Smith County and later to Navarro County.

NEW SALEM SAW- AND GRISTMILL: Just down Route 97 from the mill is a replica of the type of flatboat Lincoln might have taken down to New Orleans. (For the history of the saw- and gristmill, see chapter 1.)

ARCHAEOLOGY WALK: As mentioned in chapter 7, the son of New Salem cooper Henry Onstot, Reverdy J. Onstot, aided by other surviving residents, drew a map in 1902 that included two structures not shown on earlier maps. These were located on land northeast of the Second Berry-Lincoln Store, but unlike other features on the Onstot map, these buildings were not identified by name. Archaeological work conducted by Robert Mazrim in 1995 found artifacts at the location of those two structures and also traces of a road. The latter turned out to be remnants of what once had been the Spoon River Road.[1] The results of these investigations are part of the Archaeology Walk adjacent to the second Berry-Lincoln Store.

So, there you have it. The "short and simple annals" of New Salem and its people; the six years spent there by Abraham Lincoln and the effect those years had on him; the desolation of the site but never the loss of memories of what had been; and the reconstruction of the village, meant to convey to visitors the environment that shaped Lincoln.

Six years Lincoln lived in New Salem. Those same six years would have won for him a degree as Bachelor of Arts, at Illinois [College].... *What would a college course have done for Lincoln?...If the six years which he spent in New Salem had been spent upon a college campus would he have gone forth better equipped for the great work he had to do than he was when he left New Salem penniless, burdened with debt and with his whole library and wardrobe in his saddlebags?*

These are the questions we cannot answer. But this we know, that, defective as was his formal instruction, Abraham Lincoln was in the larger sense of the term, an educated man.

New Salem

All in all, the best thing which a college education gives to a man is his association with his teachers and fellow-students. There in the free republic of the campus he is learning how to deal with men. Lincoln learned that lesson in New Salem. New Salem has been rightly called "Lincoln's Alma Mater."[2]

NOTES

Chapter 1

1. *History of Menard and Mason Counties*, 192.
2. Mazrim, *Sangamo Frontier*, 307–08.
3. *History of Menard and Mason Counties*, 202.
4. Onstot, *Pioneers of Menard and Mason Counties*.
5. Sangamon County Deed Records, vol. C, 219.
6. Wilson and Davis, *Herndon's Informants*, 258–59.
7. Veach, *New Salem Research File*.
8. Onstot, *Pioneers of Menard and Mason Counties*, 53.
9. Wilson and Davis, *Herndon's Informants*, 420.
10. Onstot, *Pioneers of Menard and Mason Counties*, 125–26.
11. Thomas, *Lincoln's New Salem*, 50–52.
12. Onstot, *Pioneers of Menard and Mason Counties*, 127.
13. *History of Menard and Mason Counties*, 220.
14. Abraham Lincoln Presidential Library and Museum (hereafter ALPLM), *Gazeteer of Illinois*.
15. Sandburg, *Abraham Lincoln*, vol. 1, 142.
16. Onstot, *Pioneers of Menard and Mason Counties*, 157.
17. *History of Menard and Mason Counties*, 214.
18. Ibid., 216–17.
19. Ibid., 218.
20. Ibid., 219.
21. Pond, "Intellectual New Salem in Lincoln's Day."

Chapter 2

1. Reep, *Lincoln and New Salem*, 48.
2. Onstot, *Pioneers of Menard and Mason Counties*, 22.
3. Wilson and Davis, *Herndon's Informants*, 604.
4. Ibid., 250.
5. Ibid., 242.
6. Ibid., 527.
7. Ibid., 73.
8. Ibid., 253.
9. Erickson, "Graves of Ann Rutledge," 93–94, 96, 100.
10. Mazrim, *Sangamo Frontier*, 311–13.
11. Bale, "Three Generations of New Salem Pioneers," 353.
12. *Sangamo Journal*, "For Sale, New Salem Saw and Grist Mill."
13. Sangamon County Illinois Family Histories.
14. Onstot, *Pioneers of Menard and Mason Counties*, 127.
15. Baringer and Miers, *Lincoln Day by Day*, 40.
16. Ibid., 38.
17. ALPLM, Lincoln Collection, Vertical File, New Salem.
18. Onstot, *Pioneers of Menard and Mason Counties*, 152.
19. *Sangamo Journal*, "Wool Carding."
20. Onstot, *Pioneers of Menard and Mason Counties*, 153.
21. Bale, "Three Generations of New Salem Pioneers," 356.
22. Chandler, "New Salem," 523–24.
23. "Report of the New Salem Temperance Society."
24. Booton, *Record of the Restoration of New Salem*, 27.
25. ALPLM, Lincoln Collection, Vertical File, New Salem.
26. Herndon and Weik, *Abraham Lincoln*, 76–77.
27. Sandburg, *Abraham Lincoln*, vol. 2, 289; Barton, *Life of Abraham Lincoln*, 168–69.
28. *History of Menard and Mason Counties*, 292.
29. Reep, *Lincoln and New Salem*, 54–55.
30. Onstot, *Pioneers of Menard and Mason Counties*, 154.
31. ALPLM, SC 133-A.

Chapter 3

1. Sandburg, *Abraham Lincoln*, vol. 1, 178.
2. ALPLM, SC 1333-A, folder 1.
3. Sandburg, *Abraham Lincoln*, vol. 1, 175.
4. Reep, *Lincoln and New Salem*, 53–54.
5. Thomas, *Lincoln's New Salem*, 115–16.
6. Onstot, *Pioneers of Menard and Mason Counties*, 74.
7. Wilson and Davis, *Herndon's Informants*, 243.
8. Reep, *Lincoln and New Salem*, 79.
9. Basler, *Collected Works of Abraham Lincoln*, I, 118.
10. Ibid., 54–55.
11. Ibid., 262.
12. Ibid., 78.
13. Wilson and Davis, *Herndon's Informants*, 256.
14. Thomas, *Lincoln's Old Friends*, 129.
15. Ibid., 123.
16. Thomas, *Lincoln's New Salem*, 46.
17. *History of Menard and Mason Counties*, 251–52.
18. Sandburg, *Abraham Lincoln*, vol. 1, 148.
19. Reep, *Lincoln and New Salem*, 76.
20. *History of Menard and Mason Counties*, 283.
21. Wilson and Davis, *Herndon's Informants*, 72.

Chapter 4

1. Sangamon County Deed Records.
2. Wilson and Davis, *Herndon's Informants*, 427, 428 (illus.); ALPLM, Nancy Fern Pond Collection.
3. ALPLM, Nancy Fern Pond Collection.
4. Reep, *Lincoln and New Salem*, 106; ALPLM, Nancy Fern Pond Collection.
5. Tarbell, *Early Life of Abraham Lincoln*, 116; ALPLM, Nancy Fern Pond Collection.
6. Onstot, *Pioneers of Menard and Mason Counties*, 146–48; ALPLM, Nancy Fern Pond Collection.
7. Mazrim, *Sangamo Frontier*, 287; Library of Congress, Geography and Map Division.

Chapter 5

1. Basler, *Collected Works*, *I*, 320.
2. *History of Menard and Mason Counties*, 204.
3. Herndon and Weik, *Abraham Lincoln*, 67.
4. Reep, *Lincoln and New Salem*, 19.
5. Baringer and Miers, *Lincoln Day by Day*, 15.
6. ALPLM, SC 1333-A, folder 1.
7. Reep, *Lincoln and New Salem*, 22; Baringer and Miers, *Lincoln Day by Day*, 15.
8. Wilson and Davis, *Herndon's Informants*, 80.
9. Wilson, *Honor's Voice*, 25, 27.
10. Basler, *Collected Works*, *I*, 3–4.
11. Ibid., *III*, 511.
12. Wilson, *Honor's Voice*, 55.
13. Wilson and Davis, *Herndon's Informants*, 455.
14. Ibid., 107.
15. Ibid., 426.
16. Ibid., 10.
17. Basler, *Collected Works*, *I*, 7.
18. Ibid., 8–9.
19. Baringer and Miers, *Lincoln Day by Day*, 16–17; Reep, *Lincoln and New Salem*, 36; Thomas, *Lincoln's Old Friends*, 75–76.
20. Baringer and Miers, *Lincoln Day by Day*, *I*, 17.
21. Basler, *Collected Works*, *I*, 10.
22. Ibid., 9–10.
23. Ibid., 11–12.
24. Sandburg, *Abraham Lincoln*, vol. 1, 155.
25. Basler, *Collected Works*, *I*, 510.
26. Thomas, *Lincoln's New Salem*, 81.
27. Baringer and Miers, *Lincoln Day by Day*, 21–23.
28. Ibid., 23–29.
29. Wilson and Davis, *Herndon's Informants*, 171.
30. Baringer and Miers, *Lincoln Day by Day*, 29; Reep, *Lincoln and New Salem*, 41.
31. Tarbell, *Early Life of Abraham Lincoln*, 172, 174.
32. Basler, *Collected Works*, *I*, 13, 14; Baringer and Miers, *Lincoln Day by Day*, 30–31.
33. *Sangamo Journal*, "Fresh Groceries."

34. Basler, *Collected Works*, I, 15–16; Reep, *Lincoln and New Salem*, 43–45.
35. Thomas, *Lincoln's New Salem*, 115.
36. ALPLM, SC 1333-A, folder 2.
37. Baringer and Miers, *Lincoln Day by Day*, 32.
38. Ibid., 33–34.
39. Thomas, *Lincoln's New Salem*, 99; Baringer and Miers, *Lincoln Day by Day*, 73.
40. Thomas, *Lincoln's New Salem*, 102–03; Reep, *Lincoln and New Salem*, 59.
41. Onstot, *Pioneers of Menard and Mason Counties*, 48.
42. Pratt, *Personal Finances of Abraham Lincoln*, 10; Baringer and Miers, *Lincoln Day by Day*, 34–35.
43. Basler, *Collected Works*, I, 15–16.
44. Ibid., 20.
45. Ibid., 16–17.
46. Pratt, *Personal Finances of Abraham Lincoln*, 12; Baringer and Miers, *Lincoln Day by Day*, 35.
47. Basler, *Collected Works*, I, 20–21.
48. Ibid., 21–22.
49. Pratt, *Personal Finances of Abraham Lincoln*, 13; Baringer and Miers, *Lincoln Day by Day*, 37–39.
50. Baringer and Miers, *Lincoln Day by Day*, 39; Tarbell Papers; Chandler, "New Salem," 546–47.
51. Baringer and Miers, *Lincoln Day by Day*, 40; Thomas, *Lincoln's New Salem*, 43.
52. Pratt, *Personal Finances of Abraham Lincoln*, 13; Baringer and Miers, *Lincoln Day by Day*, 41.
53. Pratt, *Personal Finances of Abraham Lincoln*, 22.
54. Basler, *Collected Works*, I, 26, 28; Baringer and Miers, *Lincoln Day by Day*, 42.
55. Pratt, *Personal Finances of Abraham Lincoln*, 14.
56. Ibid., 19.
57. Baringer and Miers, *Lincoln Day by Day*, 47.
58. Ibid., 48.
59. Thomas, *Lincoln's New Salem*, 123.
60. Simon, "Abraham Lincoln and Ann Rutledge," 14.
61. Wilson and Davis, *Herndon's Informants*, 521.
62. Ibid., 13, 21, 80, 383.
63. Ibid., 607–08.
64. Ibid., 440.

65. Simon, "Abraham Lincoln and Ann Rutledge," 16–17.
66. Basler, *Collected Works*, *I*, 45.
67. Baringer and Miers, *Lincoln Day by Day*, 54.
68. Ibid., 55.
69. Pratt, *Personal Finances of Abraham Lincoln*, 58–59.
70. Basler, *Collected Works*, *I*, 47.
71. Baringer and Miers, *Lincoln Day by Day*, 55, 56.
72. Basler, *Collected Works*, *I*, 48.
73. Baringer and Miers, *Lincoln Day by Day*, 59, 60, 70.
74. Ibid., 61, 62.
75. Ibid., 63.
76. Basler, *Collected Works*, *I*, 55–56.
77. Baringer and Miers, *Lincoln Day by Day*, 66–67, 69.
78. Ibid., 68, 69.
79. Ibid., 69, 70; Basler, *Collected Works*, *I*, 75.
80. Sandburg, *Abraham Lincoln*, vol. 1, 204, 216.
81. Basler, *Collected Works*, *I*, 320.
82. Ibid., *II*, 459.
83. Ibid., *III*, 512.
84. Ibid., *IV*, 64–65.
85. Thomas, *Lincoln's New Salem*, x.
86. Pond, *New Salem Village*, 5.
87. Wilson and Davis, *Herndon's Informants*, 7.
88. Ibid., 10, 11.
89. Ibid., 21.
90. Barton, *Life of Abraham Lincoln*, 201.

Chapter 6

1. *Sangamo Journal*, "On the Road"; ALPLM, Vertical File, New Salem.
2. Onstot, *Pioneers of Menard and Mason Counties*, 156.
3. Herndon and Weik, *Abraham Lincoln*, 68, 69.
4. *History of Menard and Mason Counties*, 203.
5. Ibid., 202.
6. Onstot, *Pioneers of Menard and Mason Counties*, 79–80, 85; Taylor and Johnson, "Spirit of the Place," 176.
7. Tarbell, *Early Life of Abraham Lincoln*, 176; Mazrim, *Sangamo Frontier*, 298.
8. Booton, *Record of the Restoration of New Salem*, 31–32.

9. Onstot, *Pioneers of Menard and Mason Counties*, 157–58.
10. Taylor and Johnson, "Fragile Illusion," 266.
11. Mazrim, *Sangamo Frontier*, 279, 289.
12. *Interview of Thomas P. Reep.*
13. New Salem Lincoln League, *Lincoln's New Salem*, 10.
14. Taylor and Johnson, "Spirit of the Place," 187.
15. Reep, *Lincoln and New Salem*, 103.
16. Taylor and Johnson, "Spirit of the Place," 189.
17. Ibid., 190.
18. Reep, *Lincoln and New Salem*, 102.

Chapter 7

1. Reep, *Lincoln and New Salem*, 105; New Salem Lincoln League, *Lincoln's New Salem*, 14.
2. *Springfield Sunday Journal*, September 1, 1918, part one, 7.
3. ALPLM, Lincoln Collection, Vertical File, New Salem.
4. Reep, *Lincoln and New Salem*, 106; Taylor and Johnson, "Spirit of the Place," 199.
5. New Salem Lincoln League, *Lincoln's New Salem*, 18, 21.
6. Mazrim, *Sangamo Frontier*, 281.
7. Taylor and Johnson, "Fragile Illusion," 264.
8. *Report on Resurvey of Old Salem.*
9. Booton, *Record of the Restoration of New Salem*, 15, 16, 19; Mazrim, *Sangamo Frontier*, 281, 283, 285.
10. Taylor and Johnson, "Spirit of the Place," 175.
11. Booton, *Record of the Restoration of New Salem*, 13.
12. *History of Menard and Mason Counties*, 213–14.
13. Ibid., 20–21.
14. Ibid., 21–22.
15. Ibid., 23–24.
16. ALPLM, Nancy Fern Pond Collection.
17. Booton, *Record of the Restoration of New Salem*, 28–30.
18. Ibid., 35.
19. Ibid., 37–41.
20. Ibid., 42–57.
21. Ibid., 65.
22. Onstot, *Pioneers of Menard and Mason Counties*, 150.

23. *Illinois State Journal*, "New Salem to Be Dedicated."
24. Ibid., "Seek Pioneer Vehicles."
25. Ibid., "Dedicate Restored New Salem."
26. Booton, *Record of the Restoration of New Salem*, 74.
27. Ibid., 83; Mazrim, *Sangamo Frontier*, 313; Taylor and Johnson, "Fragile Illusion," 262.
28. ALPLM, Nancy Fern Pond Collection.
29. Onstot, *Pioneers of Menard and Mason Counties*, 146–47.
30. Ibid., 149.
31. Mazrim, *Sangamo Frontier*, 309–10.
32. ALPLM, Nancy Fern Pond Collection.
33. Mazrim, *Sangamo Frontier*, 311.
34. ALPLM, Nancy Fern Pond Collection.
35. Mazrim, *Sangamo Frontier*, 315–16.
36. Ibid., 310.
37. Ibid., 313.
38. Taylor and Johnson, "Fragile Illusion," 279.
39. Booton, *Record of the Restoration of New Salem*, 53; New Salem Lincoln League, *Lincoln's New Salem*, 24.
40. State of Illinois, *New Salem, a Memorial to Abraham Lincoln*.
41. *Life*, "As Lincoln Knew New Salem."
42. Tarbell, *Early Life of Abraham Lincoln*, 140.

Chapter 8

1. Mazrim, *Sangamo Frontier*, 287, 290.
2. Barton, *Life of Abraham Lincoln*, 200–01.

BIBLIOGRAPHY

Abraham Lincoln Presidential Library and Museum. Lincoln Collection, Vertical File, New Salem.
———. Lincoln Collection, Vertical File, New Salem, "History of Henry and Jane Sinco by Ora Scott Foltz Together with a Genealogy of Their Descendants."
———. Manuscripts, New Salem Vertical File. 1834 *Gazeteer of Illinois, in Three Parts* by J.M. Peck.
———. Nancy Fern Pond Collection, Box 1½, Folder 12.
———. SC 1333-A, folder 1.
———. SC 1333-A, folder 2.
Bale, Ida L. "Three Generations of New Salem Pioneers." *Journal of the Illinois State Historical Society* 37 (1944): 351–57.
Baringer, William E., and Earl Schenck Miers. *Lincoln Day by Day, a Chronology 1809–1865*. Vol. 1, *1809–1848*. Washington, D.C.: Lincoln Sesquicentennial Commission, 1960.
Barton, William E. *The Life of Abraham Lincoln*. Vol. 1. Indianapolis: Bobbs-Merrill Company, 1925.
Basler, Roy P., ed. *The Collected Works of Abraham Lincoln*. *I*: *1824–1848*; *II*: *1848–1858*; *III*: *1858–1860*; *IV*: *1860–1861*. Springfield, IL: Abraham Lincoln Association, 1953.
Booton, Joseph F. *Record of the Restoration of New Salem*. 2nd ed. Springfield: Illinois Department of Public Works and Buildings, 1934.
Burlingame, Michael. *Abraham Lincoln, A Life*. Vol. 1. Baltimore, MD: Johns Hopkins Press, 2008.

Bibliography

Chandler, Josephine Craven. "New Salem: Early Chapter in Lincoln's Life." *Journal of the Illinois State Historical Society* 22 (1930): 505–58.

Erickson, Gary. "The Graves of Ann Rutledge and the Old Concord Burial Ground." *Lincoln Herald* 71 (1969): 90–107.

Herndon, William H., and Jesse W. Weik. *Abraham Lincoln: The True Story of a Great Life*. Vol. I. New York: D. Appleton and Company, 1893.

The History of Menard and Mason Counties, Illinois. Chicago: O.L. Baskin & Co., Historical Publishers, 1879.

Illinois State Journal (Springfield), "Dedicate Restored New Salem Village Where Lincoln Lived." October 27, 1933, 1.

———. May 13, 1847, p. 1, col. 6.

———. "New Salem to Be Dedicated on October 26." October 15, 1933, part 3, 7.

———. "Seek Pioneer Vehicles for Park Street." October 25, 1933, 2.

Illustrated Atlas Map of Menard County, Illinois. N.p.: W.R. Brink, 1874, 43.

Interview of Thomas P. Reep by Joseph F. Booton Regarding Early Research Work on Restoration of New Salem. Petersburg, Illinois, October 18, 1934, 5. Springfield: Illinois Regional Archives Depository, University of Illinois at Springfield.

Kunigunde, Duncan, and D.F. Nickols. *Mentor Graham, the Man Who Taught Lincoln*. Chicago: University of Chicago Press, 1944.

Library of Congress, Geography and Map Division, New Salem, home of Abraham Lincoln, 1831–1837.

Life. "As Lincoln Knew New Salem." February 15, 1954, 79–81.

Mazrim, Robert. *The Sangamo Frontier: History and Archaeology in the Shadow of Lincoln*. Chicago: University of Chicago Press, 2007.

McCullough, C.S. *Petersburg and the Early Home of Abraham Lincoln, Artistic and Poetic*. Chicago: Richard Acton, n.d.

Menard County Illinois Cemetery Records. ww.rootsweb.ancestry.com/~ilmaga/menard/cemetery/1_cem_list.html.

New Salem Lincoln League. *Lincoln's New Salem: A Village Reborn*. Petersburg, IL: New Salem Lincoln League, 1994.

Onstot, Thomson Gaines. *Pioneers of Menard and Mason Counties*. Forest City, IL: T.G. Onstot, 1902.

Pond, Fern Nance. "Intellectual New Salem in Lincoln's Day." Address delivered at Lincoln Memorial University, Harrogate, Tennessee, February 12, 1938. Box 2, Folder 2, New Salem Data, Intellectual Life, Literature Society.

———. *New Salem Village: Photographic Views and Brief Historical Sketch of New Salem State Park Near Petersburg, Illinois*. Petersburg, IL: Petersburg Observer Company, 1938.

Bibliography

Pratt, Harry E. *The Personal Finances of Abraham Lincoln*. Springfield, IL: Abraham Lincoln Association, 1943.

Reep, Thomas P. *Lincoln and New Salem*. Petersburg, IL: Old Salem Lincoln League, 1918.

"Report of the New Salem Temperance Society." November 7, 1833. Springfield: Illinois Regional Archives Depository, University of Illinois at Springfield.

Report on Resurvey of Old Salem (Formerly New Salem). Done between August 29 and September 10, 1932 by Ray V. Tilly of Wood, Walraven, & Tilly, Civil Engineers of Springfield, Illinois. Illinois Regional Archives Depository, University of Illinois at Springfield.

Sandburg, Carl. *Abraham Lincoln, The Prairie Years*. 2 vols. New York: Harcourt, Brace & World, 1926.

Sangamon County Deed Records, vol. C, 219. Illinois Regional Archives Depository, University of Illinois at Springfield.

Sangamon County Illinois Family Histories. Accessed January 8, 2016. sangamon.illinoisgenweb.org/famhis.htm.

Sangamo Journal. "For Sale, New Salem Saw and Grist Mill." September 29, 1832.

———. "Fresh Groceries." January 19, 1832.

———. "On the Road from Petersburgh, Illinois, May 4, 1847." May 13, 1847.

———. "Wool Carding." April 24, 1835.

Simon, John Y. "Abraham Lincoln and Ann Rutledge." *Journal of the Abraham Lincoln Association* 11 (1990): 13–33.

Springfield Sunday Journal. "Pageant to Start Monday." September 1, 1918, part one, 7.

State of Illinois. *New Salem, a Memorial to Abraham Lincoln*. 5th ed. Springfield: State of Illinois Department of Public Works and Buildings, 1940.

Tarbell, Ida M. *The Early Life of Abraham Lincoln*. New York: S.S. McClure, Limited, 1896.

Tarbell Papers. Alleghany College. Sketch: Dr. Chandler's Story.

Taylor, Richard S., and Mark L. Johnson. "A Fragile Illusion: The Reconstruction of Lincoln's New Salem." *Journal of Illinois History* 7 (2004): 254–80.

———. "The Spirit of the Place: Origins of the Movement to Reconstruct Lincoln's New Salem." *Journal of Illinois History* 7 (2004): 174–200.

Thomas, Benjamin P. *Lincoln's New Salem*. Chicago: Lincoln's New Salem Enterprises, Inc., 1973.

Bibliography

Thomas, Dale. *Lincoln's Old Friends of Menard County Illinois*. Charleston, SC: The History Press, 2012.

Veach, Rebecca. *New Salem Research File, 1975–78*. Springfield: Illinois Regional Archives Depository, University of Illinois at Springfield, n.d.

Wilson, Douglas L. *Honor's Voice: The Transformation of Abraham Lincoln*. New York: Alfred A. Knopf, 1998.

Wilson, Douglas L., and Rodney O. Davis, eds. *Herndon's Informants: Letters, Interviews, and Statements about Abraham Lincoln*. Urbana: University of Illinois Press, 1998.

INDEX

A

Abell, Bennett Howard 39, 42, 62
Abell, Elizabeth 39, 40, 42
Allen, Dr. John 20
 birth 30
 burial site 31
 death 31
 leaves New Salem 31
 organizes temperance society 30
 settles at New Salem 30
 teaches Sunday school 30
Alley, Nelson 21, 62, 63, 64, 67, 97, 98, 108
Armstrong, Hannah
 birth 36
 burial site 37
 care of Lincoln 36
 death 37
 leaves New Salem area 36
Armstrong, John "Jack"
 birth 36
 burial site 36
 death 36
 in Black Hawk War 36
 wrestles Lincoln 36, 53, 54
Armstrong, William "Duff" 36

B

Bale, Jacob 21, 24, 33, 79, 98, 99, 102, 108
Berry, Reverend John M. 35
Berry, William F. 20, 58, 60, 65, 66
 birth 35
 burial site 35
 death 35, 66
 intemperance 35, 62
 partnership with Lincoln 29, 35, 44, 60, 62, 63, 65, 107
Black Hawk War, in 25, 35, 36, 44, 58, 61, 64, 74, 75, 76
Booton, Joseph F. 84, 89, 90, 92, 98
Browning, Mrs. Orville H. 40
Burner, Isaac 33, 96, 107

C

Calhoun, John 63, 64, 67
Camron, Reverend John M. 13, 14, 23
 birth 13
 burial site 25
 death 25
 founds New Salem 15
 leaves New Salem 25

INDEX

cemeteries
 Abingdon 33
 Avon 42
 Bethel 22
 Big Grove 37
 Concord 29
 Farmer's Point 44
 Fullerton 29
 Greenwood 45
 Hope 30
 Lillie 25
 Oakland 23, 37, 39
 Old Concord 22, 23, 25, 29, 36
 Pleasant Ridge 42
 Rock Creek 35
 Rose Hill 28, 31, 33, 34
 Sebastopol Memorial Lawn 25
 Union Chapel 46
Chandler, Dr. Charles C. 31, 65
Chrisman, Isaac 25, 27
Chrisman, St. Clair 25
Clary, William 31, 35, 53, 58, 79, 107, 109
 birth 26
 leaves New Salem area 26
 opens store and saloon 26
 operates ferry 26
Cogdal, Isaac 69

D

Davis, J. McCan 34, 47, 82

F

Ferguson, Alexander 34, 62, 102, 108

G

Godbey, Russell 64
Graham, Mentor 22, 25, 29, 39, 55, 56, 62, 65, 66, 77, 79, 97, 106
 birth 42
 burial site 44
 death 43
 helps Lincoln 43, 57, 63, 77
 leaves New Salem area 43
 teaches school 42
Green, Bowling 35, 44, 52, 53, 62, 64, 66, 68, 74, 82
 appearance 38
 birth 37
 burial site 39
 death 39
 helps Lincoln 39, 67, 77
Greene, Lynn McNulty 20, 22, 53, 68
Greene, William G., Jr. 20, 22, 44, 45, 52, 53, 57, 58, 60, 61, 62, 63, 64, 65, 66, 68, 77, 82, 84, 97
Green, Nancy 37, 38, 39, 44, 53, 67, 77
Guliher, Isaac 33, 58, 62, 107

H

Hanks, John 51, 52, 55
Harrison, Reuben S. 15, 16, 47, 67, 85
Hearst, William Randolph 69, 85
Herndon, James 29, 35, 60, 63, 107
Herndon, John Rowan 29, 35, 60, 76, 77, 107, 108
 opens store 29
 pilots *Talisman* 29, 57
 sells store to Lincoln 35, 63
Herndon, William 16, 17, 22, 23, 30, 32, 42, 45, 46, 47, 53, 55, 56, 59, 67, 68, 69, 74, 77, 80, 98
Hill, Parthena Nance 22, 27, 28, 47, 82, 97, 102
Hill, Samuel 19, 21, 33, 47, 60, 64, 82, 97, 102
 birth 26
 builds carding mill 27, 107
 burial site 28

Index

death 28
leaves New Salem area 28
opens store 26
residence 27, 92, 96, 102, 103, 108
serves as postmaster 21, 27
History of Menard and Mason Counties, Illinois, The 18, 80, 92

J

Johnston, Robert 34, 96, 107

K

Kelso, John "Jack" 20, 34, 57, 77, 107
leaves New Salem 34
student of Shakespeare and Burns 34, 77
Kirkham's Grammar 43, 55, 77

L

Lincoln, Abraham
admitted to bar 73
and Ann Rutledge 22, 23, 67, 68, 69
and Mary Owens 39, 40, 41, 42
arrival at New Salem 51, 52
clerks in Offutt store 44, 53, 54, 82
financial difficulties 46, 63, 65
impact of New Salem 20, 76, 77
improves education 43, 54, 55, 76
in Black Hawk War 35, 36, 44, 58, 59, 61, 76
partnership with William F. Berry 29, 35, 44, 60, 61, 62, 63, 107
pilots *Talisman* 57
runs for legislature 57, 59, 60, 65, 70, 78
serves as postmaster 27, 62, 67
serves as surveyor 33, 63, 64, 67, 70
serves in legislature 66, 72
studies the law 66, 67

wrestles Jack Armstrong 36, 53, 54
Lukins, Peter 25, 33, 34, 70, 96, 108
founds Petersburg 25

M

Mazrim, Robert 24, 50, 98, 99, 109
McNamar (McNeil), John 16, 17, 21, 26, 60, 79, 108
arrives at New Salem 28
betrothed to Ann Rutledge 23, 28, 67
leaves New Salem 28
opens store 108
Miller, Joshua 34, 107
Morris, Philemon 25, 34, 62

N

New Salem
amusements 17
clothing 19, 20
commercial center 16
cooking 19
decline and disappearance 72, 78, 79, 80
description 13, 14, 18
farming 20
intellectual life 20
plats and maps 47–50
religion 17, 18
restoration 85, 86–104
temperance society 17, 30, 35
New Salem Lincoln League 99, 105

O

Offutt, Denton 31, 32, 33, 51, 52, 53, 54, 75, 92, 109
arrives at New Salem 31
hires Lincoln 44
leaves New Salem 31, 57, 109

Index

Old Salem Cumberland Presbyterian
 State Chautauqua Association 85
Old Salem Lincoln League 84, 85, 86,
 89, 99
Onstot, Henry 21, 50, 90, 92, 97,
 108, 109
 cooperage 29, 95, 100, 102, 107
 leaves New Salem 89, 96
 operates tavern 97, 106
 settles at New Salem 29
Onstot, Reverdy J. 50, 85, 109
Onstot, T.G. 17, 18, 19, 22, 25, 47,
 84, 97, 98
Owens, Mary 39, 40, 41, 42

P

Pantier, James 25, 30, 62, 108
Petersburg 23, 25, 28, 29, 31, 32, 33,
 34, 36, 37, 39, 47, 51, 62, 70,
 72, 77, 78, 79, 80, 82, 84, 86,
 89, 90, 96, 99, 103, 106, 107,
 108
Pioneers of Menard and Mason Counties 19,
 22, 47, 97, 98
Pond, Fern Nance 76

R

Radford, Reuben 29, 35, 44, 61, 63, 64
Reep, Thomas P. 38, 84, 85
Regnier, Dr. Francis 25, 92, 96, 102, 108
 burial site 34
 death 34
 moves away 34, 108
 settles at New Salem 34
Rutledge, Ann 55
 betrothal 23, 28, 67
 birth 22
 burial site 22
 death 22, 28, 39, 44, 67, 68
 romance with Lincoln 67, 68, 69, 100

Rutledge, James 13, 20
 birth 13
 burial site 22
 death 22
 founder of New Salem 14
 moves to Sand Ridge 22
 opens tavern 21
Rutledge, James McGrady 68
Rutledge, Mary Ann 13, 21, 22, 28,
 67, 108

S

Sangamo Journal 24, 27, 57, 61, 70, 73
Sangamon River 13, 14, 18, 24, 26,
 35, 51, 52, 57, 62, 70, 78, 79,
 85, 100, 103
Short, James S. 23, 45, 46, 66
Sinco, Henry 25, 34, 52, 108
Speed, Joshua 74
Stuart, John T. 66, 73, 75, 77

T

Talisman 29, 57, 63, 78
Tarbell, Ida M. 47, 60, 80, 82, 104
Trent, Alexander 26, 35, 58, 62, 64,
 107
Trent, Martin 35, 62, 64, 107

V

van Bergen, Peter 64, 65
Vance, John C. 43, 55, 56
Vandalia 40, 66, 69, 70, 72

W

Waddell, Martin 34, 62, 92, 96, 102,
 107
Warburton, George 25, 33, 58, 70,
 95, 108
Whary, David 25, 62

ABOUT THE AUTHOR

Photo taken by Allison Di Cola.

Joseph M. Di Cola was born and raised in Chicago. He is an author of *Chicago's 1893 World's Fair* published by Arcadia Publishing in 2012 as part of the "Images of America" series. A recent article of his appeared in the summer 2014 issue of *Chicago History* entitled "The Jackson Park Caravels." He earned a baccalaureate in history from Shimer College, Mount Carroll, Illinois, and his master's in educational leadership and doctorate in educational psychology from Northern Illinois University at De Kalb. Joe has an avid interest in Abraham Lincoln going back to when he was eleven, and when not engaged in reading and research on historical topics, he likes to read, cook, travel and spend time with family and friends, especially his grandsons, Joseph, Christian and Maximus, to whom this work is dedicated. He currently lives in Troy, Ohio.

*Visit us at
www.historypress.net*

This title is also available as an e-book